# DRAWING AND CARTOONING 1,001 CARICATURES

# DRAWING AND CARTOONING 1,001 CARICATURES

## Dick Gautier

A Perigee Book

A Perigee Book
Published by The Berkley Publishing Group
200 Madison Avenue
New York, NY 10016

Copyright © 1995 by Dick Gautier
Book design by James McGuire
Cover design by Dick Gautier.

First edition: April 1995

Published simultaneously in Canada.

**Library of Congress Cataloging-in-Publication Data**

Gauter, Dick.
    Drawing & cartooning 1,001 caricatures / Dick Gautier.—1st ed.
        p.    cm.
    "A Perigee book."
    ISBN 0-399-51911-4
    1. Cartooning—Technique.    I. Title.    II. Title: Drawing and
cartooning 1,001 caricatures.    III. Title: Drawing & cartooning one
thousand one caricatures.
NC1320.G39   1995
741.5—dc20                                                94-23817
                                                            CIP

Printed in the United States of America

10   9   8   7   6   5   4

# Contents

The human face: a great creation
An endless source of inspiration
We're all the same, yet different creatures
With varied arrangements of our features
A veritable sea of variation
From every race and place and nation
Our facial flavors vast and myriad
Created over a long, long period
We come in every shape and size
And when you think you've seen it all—Surprise!
Another face pops into view
A different one that's fresh and new
It's more amazing I guess because it
Is still a mystery how He does it

Faces full or narrow, wrinkled
Some with freckles liberally sprinkled
Different shades and different textures
Some provide fascinating mixtures
The human face upon inspection
Reveals a wide range of complexions
Black or yellow, pink or red
Brown or grayish (this type looks dead)
Skin that's peachy, pasty, ruddy
Olive, tanned, blotched, or muddy
Some turn bright red in their passion
Swarthy, acned, pockmarked, ashen
You can often tell the mood we're in
Just by looking at our skin

Our faces change just like the tide
To reveal what's going on inside
When we're suspicious our eyes narrow
If worried our brows knit and furrow
When pleased, we smile and show our teeth
Our outer shows what's underneath

Smiles come broad, smug or tight
Grins slant to the left or right
Frowns, grimaces, pouts, moues
We contort faces so many ways
The subtlest thoughts or mad obsessions
Are revealed through our expressions

Smiling makes our lips unsheathe
And exposes to the world—our teeth
Teeth come in white, some filled with gold
Long and short, cracked and old
Snaggletoothed or sharp like fangs

One that curves or twists and hangs
Some are perfect, some are rotten
(Guess that toothbrush was forgotten)
Some just gleam when good news comes
Others smile and—mostly gums
Teeth are buck, or underbite
Dingy yellow, false or bright
Some are pearly, wall to wall
While others have none left at all

Some ears they hug the head so tight
While others seem designed for flight
Shell-like, or floppy like a beagle
Some have the wingspan of an eagle
Small ears with lobes project finesse
And some look downright Dumbo-esque

Chins come pointed, dimpled or square
Some are doubled, covered with hair
Many are weak and some heroic
Others nearly Paleozoic

Lips are shaped as curvy, wavy
Others retain signs of gravy
Lips can pout, protrude, or flap
Jut like a visor from a cap
Some stick out so you could say
"Why this looks like a handy tray"
They're generous, stingy, firm, insistent
Or chapped and sometimes nonexistent
Bee-sting lips, or moist and sensuous
Other lips are full, adventurous
They're thick, they're thin, they're flat, they're mean
And every size and shape between
Some look so red, they're almost edible
A wide variety, most incredible

Noses, too, have many looks
Containing bumps and moles and crooks
Noses fine and aristocratic
Nostrils cavernous or flare dramatic
Roman noses, upturned and haughty,
Cyrano-esque, or flat and snotty
Others sharp as any sword
Some come bulbous, like a gourd
I've seen snouts so small and neat
While some are lifted just to eat
Broken, downturned, broken veins
Some seem that they'd require reins
There are more types than one supposes
In the wide world's vast array of noses

Eyes are twin pools of desire
While others squint, or shine with fire
Bulging eyes or beady ones
Deep-set eyes, and needy ones
Tear-filled, bloodshot, those that stare
Shifty, sheeplike, ones that glare
Bedroom eyes that say "Come hither"
Or frigid stares that wilt and wither

We frame our faces with our hair
That wondrous stuff that grows up there
Some hair is fine, kinky or coarse
Or uncontrollable, and even worse
Hair comes in shades not dreamed of yet
Not just redhead, blond, brunette
Hair is done in every hue
There's carrot-topped and punky blue
Multicolored, striped, or peach
Streaked with dyes and tons of bleach
We press it, braid it, plait it, curl it
Tease it, blow it, then unfurl it
We wear it tight, we wear it loose
We oil it, gel it, use our mousse

It's long, it's short or don't have any
Some stretch a few to look like many
We brush it, cut it, use our creams
Now we even shave in names of teams
With brilliantine we try to slick down
Hair that's impossible to stick down
It's long and flowing, or short and bushy
Or wild or furry, flowing, cushy
It's greasy, flowing, stiff or curly
And some poor guys they lose it early
Men choose sideburns, mustaches, beard
To be hirsute, or cute and weird

This all is part of God's great plan
So we can spot our fellow man
Without these differences who'd be who?
Maybe you'd be him or she'd be you
Are you my wife, is he my boss?
Are you my friend? We'd all be lost
The only difference would be a name
So I say thank God we're not the same
And of course there is no other place
That captures this like the *human face*

That little poem of mine is merely an introductory way of reminding you of the incredibly wide variety of features and faces available for you to caricature; as Carl Sagan would say, "billions and billions" of faces, all different, all containing their own unique characteristics and personalities. The multitudinous faces in our world are as plentiful and as unique as fingerprints, unless you embrace the "Doppelgänger Theory," that we all have a twin somewhere in the world, but that would suggest that God got lazy and only wanted to do half the work, so I have a problem with that concept. One thing I know for certain—there are more faces out there to caricature than one could possibly do in ten lifetimes. What a feast! With caricature the world is indeed your artistic oyster.

# FOREWORD

Before we get started, let's define our terms, shall we? What exactly is a caricature? I think that if we were to ask ten people the definition of the word "caricature," we'd probably come up with ten different, though slightly related, answers. Caricature, in a literary sense, is an exaggeration of themes or ideas that reaches ridiculous proportions, a distortion of the original thought. It's also used handily when referring to a personality who has gotten too broad or given in to showy or unnecessary histrionics, hence the expression "He's become a caricature of himself," meaning that he's become a victim of his own style, that he has exaggerated his own mannerisms to the point of ludicrousness. All of these definitions actually help to point to the ones that we're going to be using in this book. Exaggeration. Distortion. Ridiculous. Ludicrous. But we've neglected one vital word—Humorous.

Caricature is born of humor, although it's perceived in some circles as a cruel art. I don't agree, but if that is true, then what shall we call those preciously cute, harmless little pastel drawings that sidewalk artists churn out at fairs? The truth of the matter is that caricature can run the gamut from gentle to savage, mild to wild, and it always possesses an element of ridicule, however slight, but I feel that that should be tempered with good humor. Mean-spirited comedy is never funny. Naturally the more you distend, warp, pull, tug, inflate and distort the features, the more outrageous and/or caustic the caricature becomes, and the less you exaggerate, the more a kinder, gentler version emerges. There is a third choice available and that is the "portrait charge," a French term meaning a blown up (as in inflated) portrait. It consists of a fairly straight portrait with only one element or feature slightly caricatured.

3

Incidentally, I've found "caricature" to be one of those words that on occasion stumps the average person. It's often mispronounced, by the uninformed or confused, as "character," as in "Hey, will you do a character of me?" Others seem to have a problem making a distinction between a cartoon and a caricature. For the record, a cartoon is generally a simple sketch or a humorous drawing of a nonspecific, hence unrecognizable, person, while a caricature, to live up to its real meaning, is a drawing, usually of a humorous nature, but always distorted, of a specific person, whether that person is your Aunt Griselda or some celebrity; it is a real person with a recognizable face. Oddly enough this bit of misspeak, using the word "character," is not actually that far from the intention of caricature: to express, reveal, or capture character through caricature. In my view, a good caricature should, more than merely distorting humorously, also project something of the inner person. Not to wax profound here, but Freud did call caricature an "unmasking," and I believe there is some truth in that.

Caricature has, in the past, been a powerful tool in the hands of the political satirist, the renegade, the restrained, civilized anarchist. It was a potent weapon capable of reshaping careers, deposing kings and even aiding in capturing fleeing criminals (the notorious Boss Tweed/Thomas Nast incident), and caricature has in its time even aided in electing presidents, by ridiculing the opposition to such an extent that they could no longer be taken seriously. The target of the caricaturist's pen was reduced, in the minds of the voters, to a few humorous symbols: bushy brows, skinny neck, sneaky eyes, wild hair, or whatever. And remember that caricature had the advantage of crossing over lines of illiteracy: everyone could recognize that well-known political figure lampooned in the daily newspaper. Caricature has even sufficiently aroused the ire of certain politicians (who I'm sure were its unwilling victims) to cause them to attempt to pass legislation to prevent caricatures from appearing in daily newspapers. This was tried on several occasions, but thankfully these attempts all failed . . . otherwise I wouldn't be writing this book, I suppose.

In today's world caricature's fangs have been blunted a bit by the mass media, but it still remains a constant ally of political cartoonists and illustrators and is in great demand in magazines and newspapers, even occasionally in the advertising world—and let's not forget those sidewalk artists.

This book is aimed at the student or artist who wants to broaden and expand his or her artistic horizons or learn to introduce elements of humor into his or her work. Michelangelo himself was accused of caricature because he painted hypertrophic bodies in his murals that certainly were exaggerations of the human form. I'm going to attempt not only to instruct you in how to approach a caricature from a draftsman's point of view, but also to guide you toward some other important caricature-making decisions, such as how to choose the correct and/or most beneficial angle, point of attack or slant in order to fully realize the subject (or "victim" as some caricaturists prefer to characterize them); or whether a profile or full-face or three-quarter view is best to use and why. Remember that revealing only half a face reduces its dynamics by half. However, some profiles (like the great John Barrymore) are so arresting and magnificent that you only diminish their importance by doing them full face. I'll give you a few examples of these various choices as we proceed.

And please remember that, bottom line, there is no one correct approach to a caricature, only subjective ones. Where one artist might choose to attack the nose first, another might begin with the head shape, while yet another could feel that capturing that whimsically soft quality in the eyes is paramount . . . Yet all of them, having taken totally different roads, can end up producing excellent drawings and likenesses. So no matter what I say or suggest in this book—THERE IS NO FORMULA.

Furthermore, let me be clear, I only suggest these approaches as guidelines for you to experiment with; if you don't feel comfortable with them, by all means go off on your own artistic tangent, pursue the work from your own unique angle. If it's successful, great . . .

if not, you might want to return to my techniques. Teaching is, after all, only a set of carefully thought out shortcuts ending, one can only hope, in the assimilation of some of these concepts by the student.

Also, I'm going to place my terribly fragile ego aside and include some of my failures. You'll see preliminary sketches where I failed, in my opinion, to achieve the desired resemblance, and how I made the spatial adjustments or amendments that ultimately led me to a more satisfactory caricature.

We'll explore the standard measurements of the human face and how the variations in spatial relationships occur, thereby giving each of us our individual identity. I will demonstrate how, once you have achieved that basic resemblance, to distort, play with or on occasion even delete features, etc., in order subsequently to arrive at a humorous version of that face while still maintaining its recognizability.

And may I give you a friendly word of warning about people's reactions to their caricatures: joy, laughter, some form of appreciation are the usual responses, but on occasion you may encounter healthy doses of resentment, anger, denial. I've personally found caricature to be a little litmus test of people's sense of humor regarding themselves. Do they really take themselves that seriously that they can't laugh at a drawing that highlights their flaws in a humorous way? A person of my past acquaintance was so disturbed by a caricature I did of them (and believe me, it was more than kind) that they were very opposed to my using it in a book. This kind of person obviously is plagued by such low self-esteem (Here comes the lay analyst!) or such an unrealistic view of their physical allure that they can't bear to see themselves in anything but a flattering light. Ah, the comfort of self-delusion. Fascinating what silly little drawings can

evoke and reveal. So be forewarned and try to scope out the personality of the person you are about to caricature.

And please, for your further self-protection, don't, after having gained some ability, ruthlessly begin to ravage your fellow students, friends, or family with a series of devastatingly cruel caricatures, only to get shunned by them. Approach this carefully and tactfully. People are sensitive regarding their looks, so be sensitive to their feelings. This may sound a bit contradictory, but I guess the bottom line is don't be mean-spirited, always come from a spirit of fun and you'll do just fine.

When I started this book, I hadn't been caricaturing as much as I used to. I'd been involved in "Bodies in Motion" and other aspects of illustration, so I found that it took me more than a little while to regain my "eye." But the more faces I did over the course of a few weeks, the easier it got. I could suddenly "see" again. I could hone in on the flaws, if you like, or let's say rather the departures from the norm, exaggerate them and capture rough likenesses pretty easily. It's like any muscle—exercising makes it more flexible and dependable and stronger.

That leads me to a very important point, which is . . . sketch people everywhere (preferably without their spotting you, I hasten to add). Hone in on and sharpen that visual insight. The more you indulge this, the better you'll be. When I go to restaurants, I bring my sketchbook along, and in between bites, I try to quickly capture essences of the faces that surround me (a pastime often found irritating by my dinner companions). Or if you're at the park, waiting in the doctor's office, wherever, try to nail every face you see in simple swift strokes. Try for an instant resemblance with as few lines as possible. There's no better exercise.

Here are some pages of sketches I've done of
people caught in the act of eating, talking,
waiting for the waiter, thumbing through
magazines, etc. It's a great exercise for sharp-
ening your powers of observation.

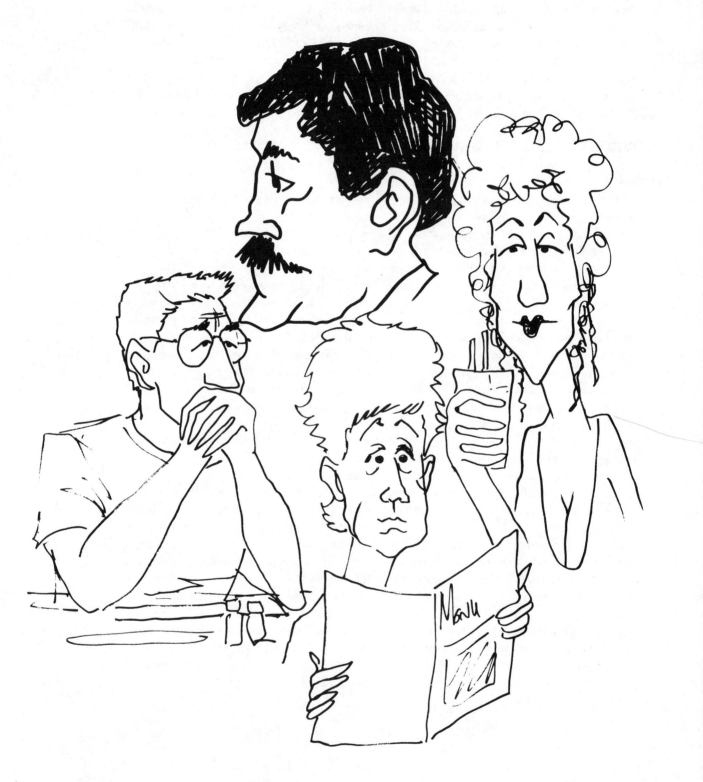

6

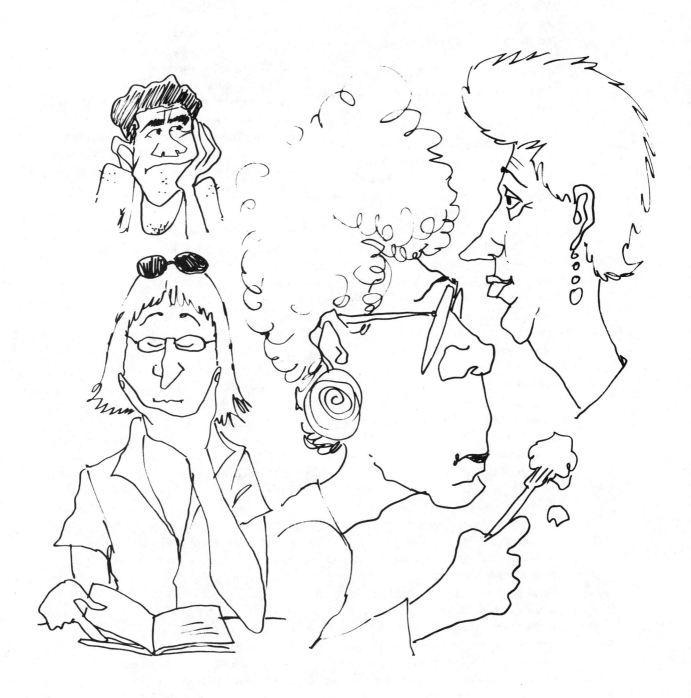

One of the most important tools for the caricaturist is a keen sense of perception, visual perspicacity; it's mandatory that we develop that hyperawareness in order to capture those sometimes terribly subtle differences that distinguish us from one another. In caricature we exaggerate: we shorten, lengthen, inflate, compress, minimize, shrink, and expand... We play with and distort the relationship among the features while still maintaining (or on occasion even increasing) the resemblance.

I guess what I'm encouraging you to do, in a sense, is to look at people a little more critically. Do they have long upper lips? When they smile, do a lot of gums show? Are their hairlines receding in funny ways? Is her hairdo wrong for her face? Does he have a mass of wrinkles around his eyes that multiply when he smiles? These are the things that you must see, that most people tend to gloss over. Most people are not terribly observant; I'm asking you to become observant in a terribly hypercritical way. You can't draw what you can't see, and you must learn to see the subtlest deviation from the norm, capture it and then exaggerate or minimize it. Powers of perception: the first giant step.

Caricature also requires, on occasion, a large helping of trial and error. Speaking for myself, some faces pose such a challenge that I find myself doing as many as fifty or sixty versions before finally arriving at what I consider to be a good caricature.

Through years of honing that sense of hyperobservation, I also find that I'm able to recognize people more easily, even at a great distance. I can spot them just by the set of their shoulders and the tilt of their head or their jaw mass. I'm really recognizing the masses of each person's facial and head area. Furthermore, subtle changes in appearance pop out at me; if a person gains or loses weight, indulges in cosmetic surgery, grows a mustache, or shaves one off—little seems to escape my detection now. I guess I'm actually projecting the image of that person inside my head and comparing it with the old version I had drawn there, so the changes become terribly apparent to me. This talent can be a curse. I won't elaborate here, but I'm sure you can figure it out. I guess people just don't always like to be scrutinized that carefully.

When I take on a new face, I like to think of it as a new adventure, a clean canvas. I like to assess that face from an almost visceral point of view. What jumps out at me first? What captures my attention and imagination? The face shape, the hair, the nose, that slightly lopsided smile? What dominant feature defines this person? What is it that you associate with this person when you look at his or her face? If it's someone you know well, try to wipe your mental slate clean and then look at the person with a fresh perspective. What do you see first? What defines the face as opposed to others?

In this book I've done primarily ink line drawings, and a few in grease pencil and soft pencil, but I've also used one of my favorites, "smeared pen technique" for lack of a better term, where I moisten my fingertip and smudge the ink to produce shading and more nuance in the drawing. But I encourage you to pursue caricature in any medium that you're comfortable with: charcoal, pastels, oils, acrylics, or whatever you choose as your favorite medium. Three-dimensional caricatures are extremely effective; clay sculpture or masklike bas-relief heads turn out very well. Other artists opt to use inanimate objects, such as apples or plastic toys, as the basis of caricatures. This is also a way to express support or disdain for the person being caricatured, depending upon what inanimate object you use. For instance, to go directly to the obvious, if you were to use a lemon as the basis for a head, the viewer would immediately jump to the natural conclusion that this person is regarded as sour, or a lemon, as in mechanically deficient cars. Collage is also a fine medium for caricature. One of my favorite artists tears portions out of the newspapers and pastes them together into devastatingly funny and stylish caricatures. So I encourage you to experiment with the entire spectrum of arts-and-crafts materials to discover your own inimitable style.

As far as plain old pen or pencil drawing goes, and this admittedly is a strictly personal choice, I prefer doing my initial sketches on newsprint (very cheap), and then for the finished drawing I like to use vellum (fairly expensive) or any other hardy, heavy tracing paper. Let me explain why . . . It allows me to change a promising sketch easily without having to start over again from scratch. I use this paper as a way to fix sketches that are partially successful. I take the drawing I want to amend and place it underneath a sheet of vellum and trace through the successful elements, then I start sliding the initial sketch around underneath until the features that I feel are misplaced move into a better position.

It takes a little trial and lots of error, and persistent scooting around of the sketch underneath, but I find it really works. The desired resemblance will really pop out at you at a certain point, then you make the adjustments, redraw that portion, and carefully complete the sketch. *Voilà!*—instant improvement. It's very gratifying and it's fun to watch as it helps you to deepen the resemblance in the caricature.

Now gather up your materials . . . pens or pencils, pads, a little patience, lots of persistence, and a dash of perspicacity . . . and let's go about the business of drawing people's faces funny—caricature.

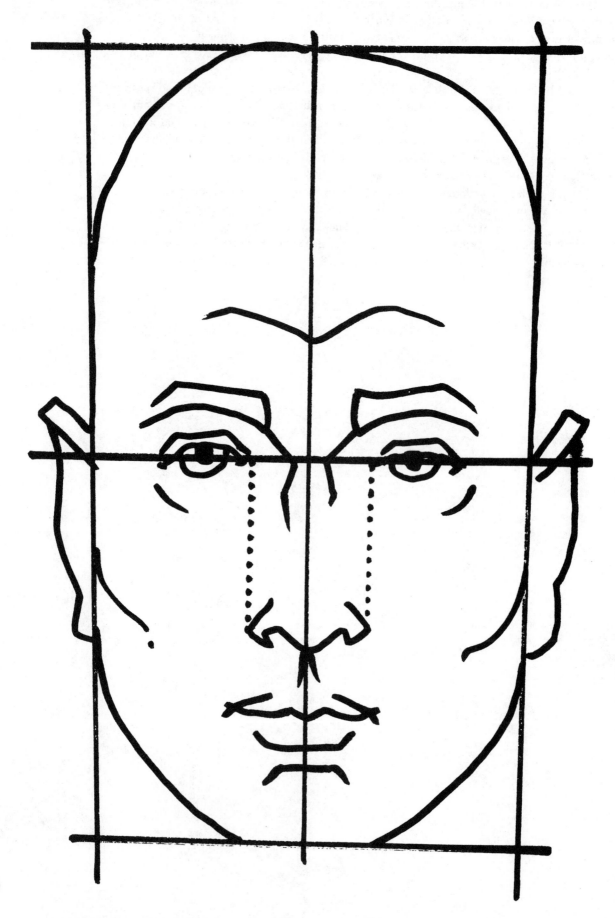

# BASICS

All right, first off let's deal with some down-and-dirty basics such as head shapes, features, and hair . . . yes, hair—as framing is critical to a painting, so the hair is to a face. We'll also get into how a pretty good likeness can be achieved without even using all the features, merely by concentrating on the basic areas of the head: the hair, face, cheeks, and brow. You'll be surprised at how effectively a caricature can be done just by using these elements in the proper relationship to one another. The difference between the measurements of the features on your face and mine is only a matter of millimeters. So, although we look nothing alike, the differences between us are as subtle as can be. With these things in mind, let's get under way and discuss a few rudiments. We have to establish a "norm" before we can have an "abnorm"; we have to have an ideal against which we can measure any corruption, distention, or distortion of that perfect paradigm.

I call this guy Norm. Why? Well, after all, he represents the average, or so-called "normal," head. His (or her, call her Norma if you wish) features are perfectly balanced and distributed. There's no deviation from the standard, hence Norm is devoid of any character.

Now, who came up with this so-called "ideal"? I can't answer (consult the anthropologists and sociologists for that one), but nevertheless these dimensions are the criteria upon which we judge handsomeness and beauty, at least in the Western Hemisphere.

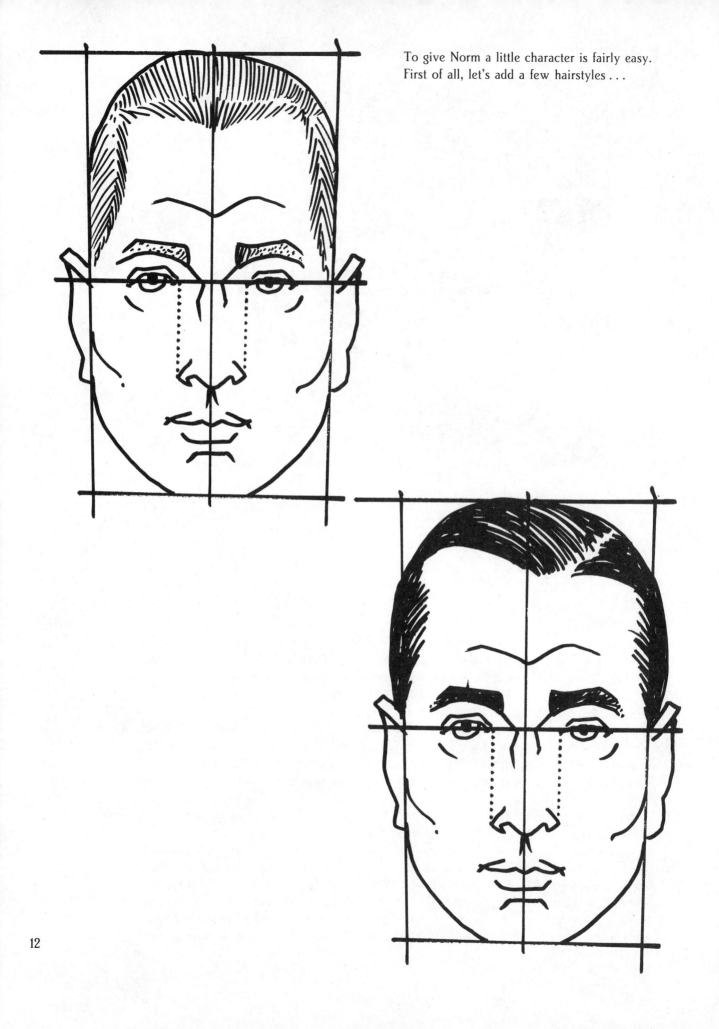

To give Norm a little character is fairly easy.
First of all, let's add a few hairstyles . . .

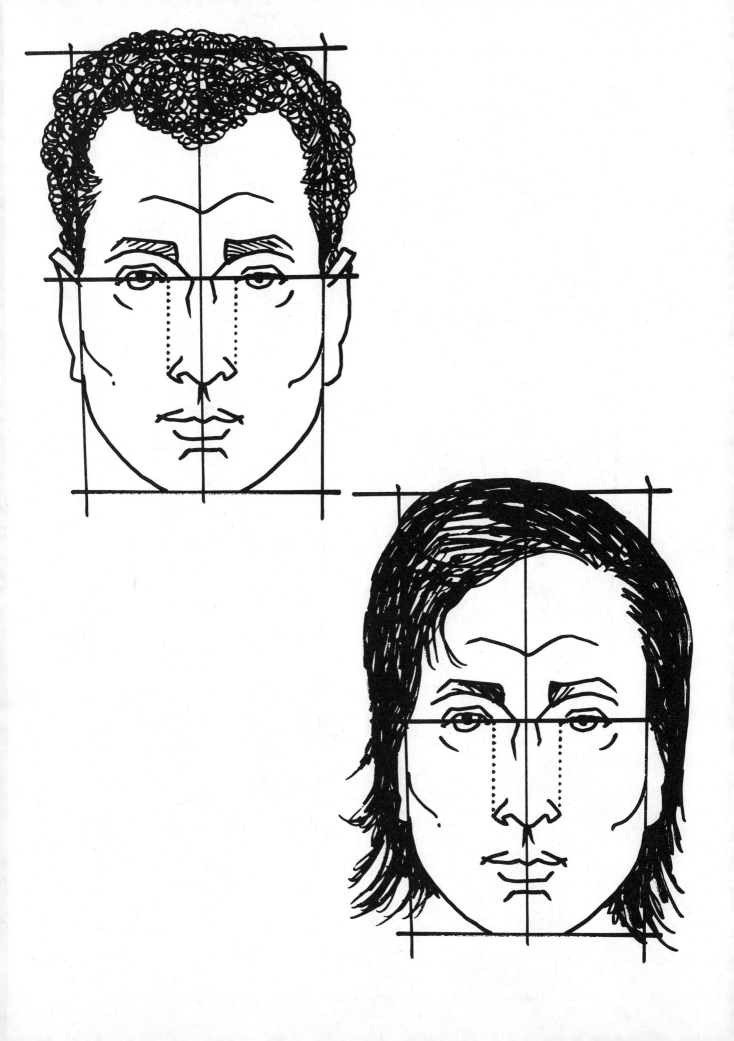

Or let's try on some different noses.

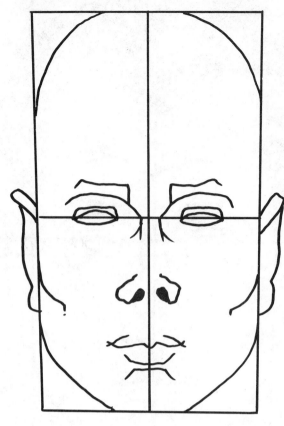

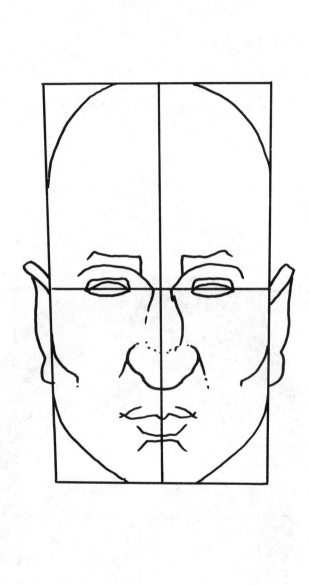

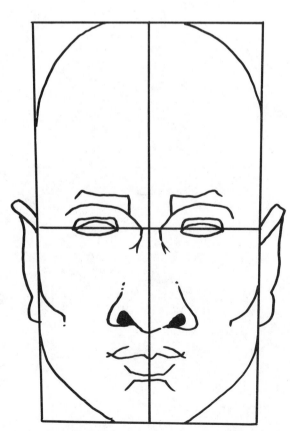

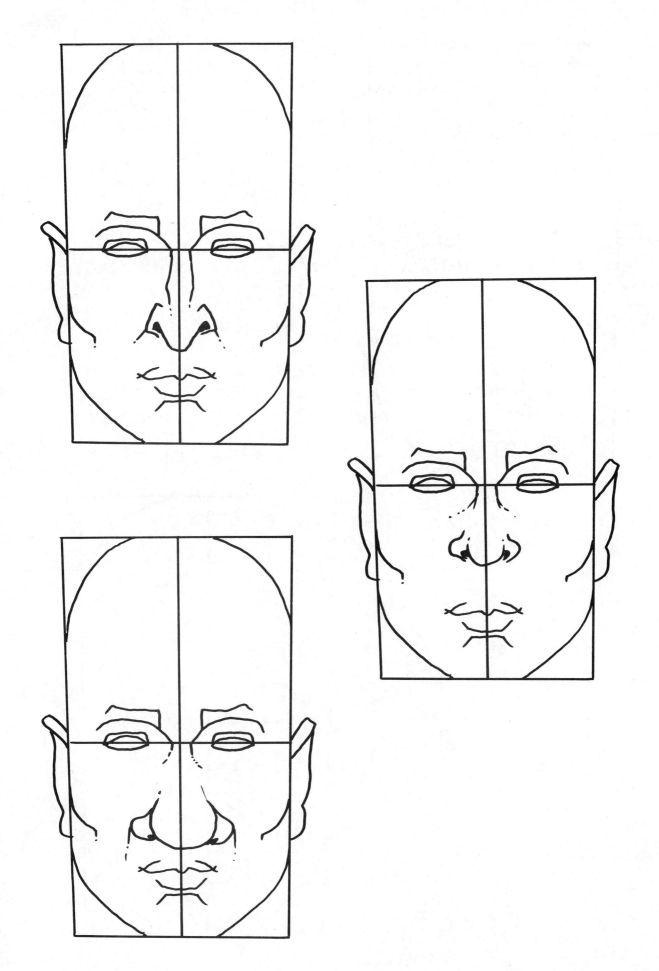

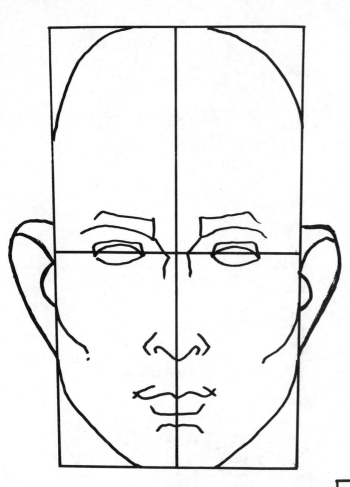

And here's how the addition of ears affects Norm's overall look.

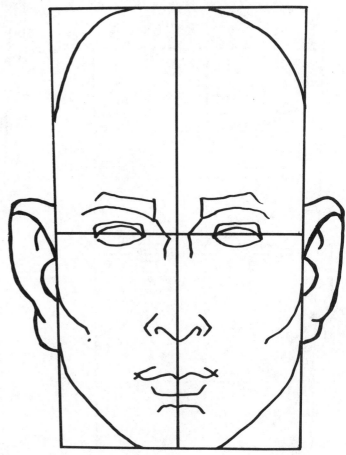

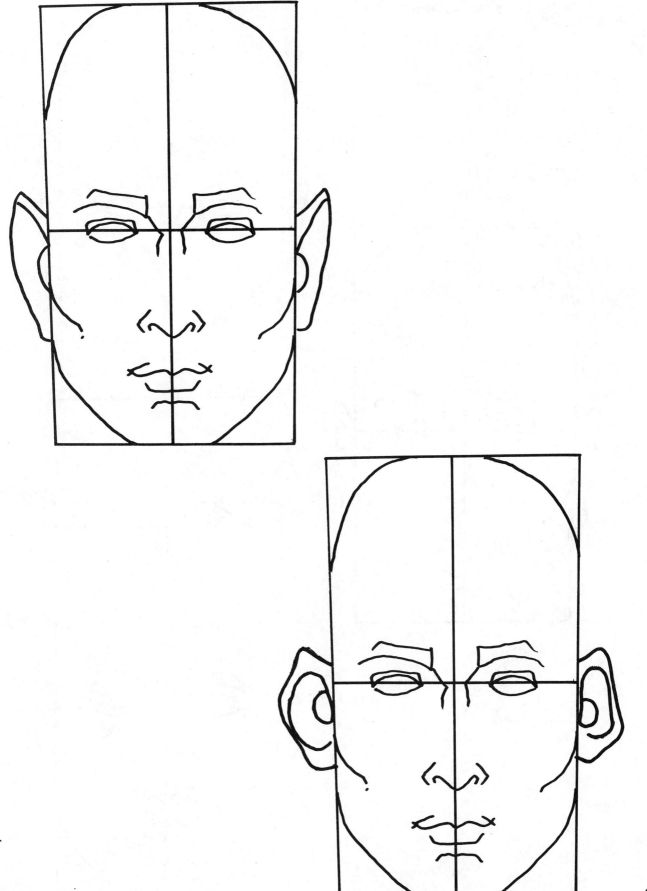

Different mouths also alter the appearance.

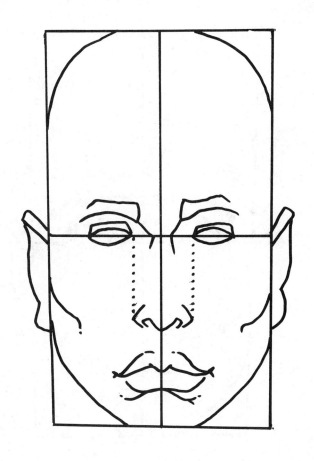

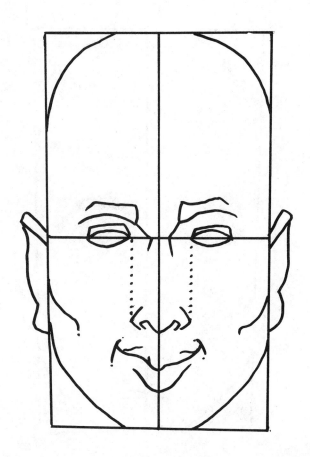

As do eyes.

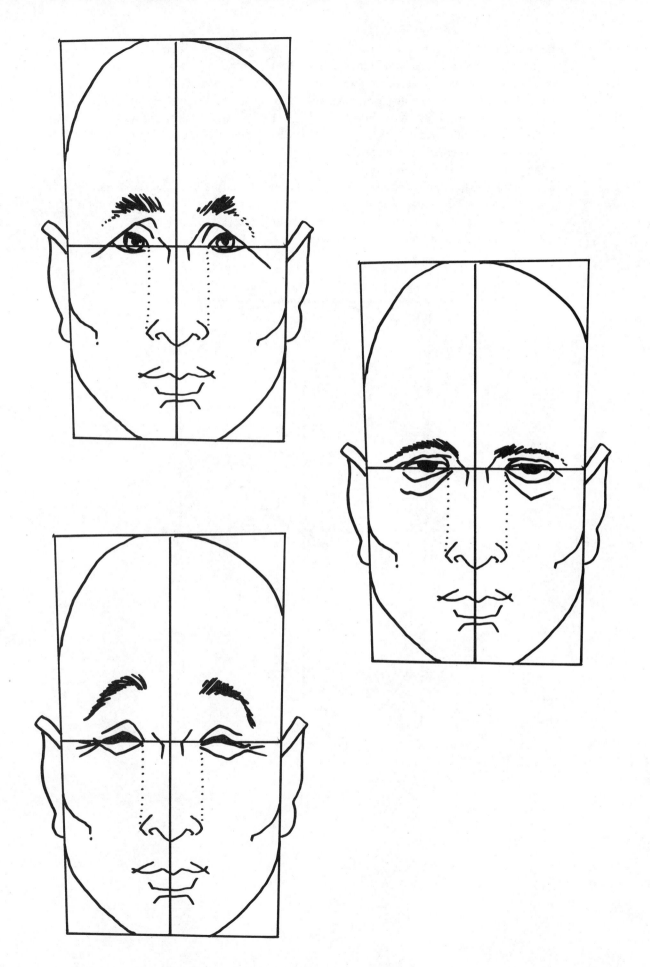

So you see that insofar as features go, you could actually use sort of a "one from column A, one from column B" technique. Since most features fall into broad categories anyway, and there are only a few elements to deal with—hair, mouth, nose, eyes, ears, head shape, chin—you could conceivably combine a random set of features and sooner or later find someone who would resemble your fictional creation ... the "infinite monkeys with an infinite number of typewriters" concept. And believe me, it can happen. When I was a teenager, I had drawn what I considered to be an outrageously funny face, stepped aboard a bus an hour later, and sat right next to the man whose face I had just created. I stared at him in numb amazement, not believing what I saw. He thought I was weird, and of course ... he was right.

Now let's take Norm's face and shift his features around a bit. Here I've made the eyes a little closer ...

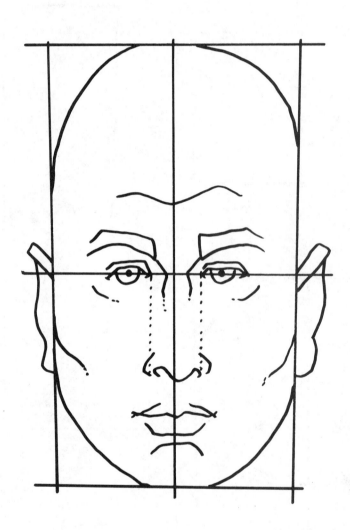

Elongated the nose . . .

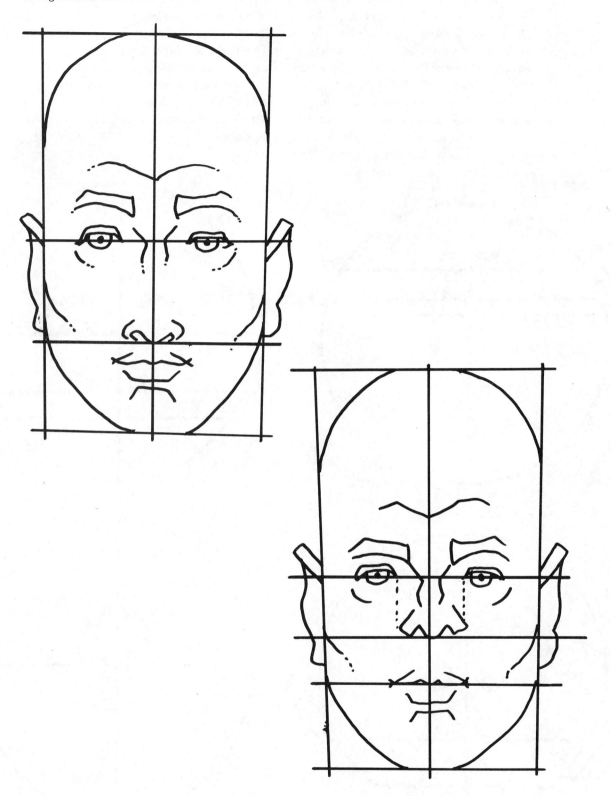

And shortened it . . .

This simple demonstration just goes to show you how little it takes to alter someone's appearance radically.

Here I've done a few generic cartoon faces inside a circle to demonstrate how, just by moving the features higher or lower in the circle, we can come up with completely different characters. The same applies to caricature. Where are the person's features located? If the person has a low forehead, then the features appear crowded, but if the forehead is high, or if it's a man and he's losing his hair, his face has an open feel to it.

Some people have extra long upper lips, which tend to make their mouths look as though they're where their chins should be. The reason for this is that the spaces between the features are different and make the features themselves appear to be different. These are called "spatial relationships," and that phrase is, I believe, the absolute key to successful caricature.

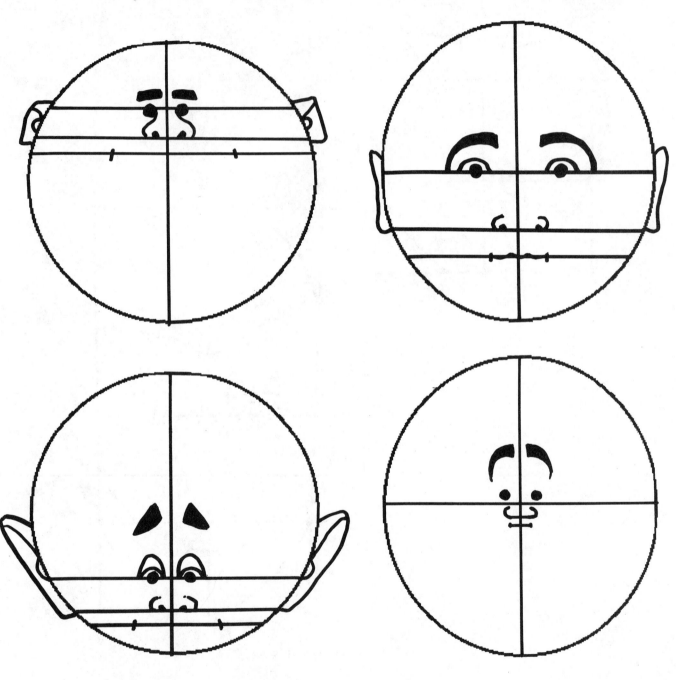

So you see features alone do not a caricature make. It's quite like the Morse code concept: it's not the dots and dashes but the pauses *between* them that the radio operators read. It's all of the elements—the head shape, the features and their relationship to one another—that are culpable in the crime of caricature. However, some features fall into the dominant category, while others are subdominant. After establishing some general guidelines for you, I want you to begin making the determination as to which features fall into which category.

But before we get into that . . .

Have you ever recognized a friend from blocks away? We all have, but what did you see that allowed you to recognize the person so readily? The posture, the build, the shape of the head, the hair? Obviously you could not actually see the features at that distance, so the recognizability factors, build and clothing aside, were the masses of face, brow, and hair.

Since a portrait or a caricature is a series of "spatial relationships" (there's that phrase again) in harmonious conjunction with one another, it's possible to capture a fairly strong resemblance merely by using only those primary masses.

In approaching a face, I immediately and instinctively prioritize the features. What to start with? What's the dominant feature, the subdominant? Which feature, if it were to be erased, would wipe out the resemblance totally? Could you do a decent caricature and eliminate one feature entirely? Does that feature really contribute to the resemblance or is it expendable? Don't touch that remote. Stay tuned.

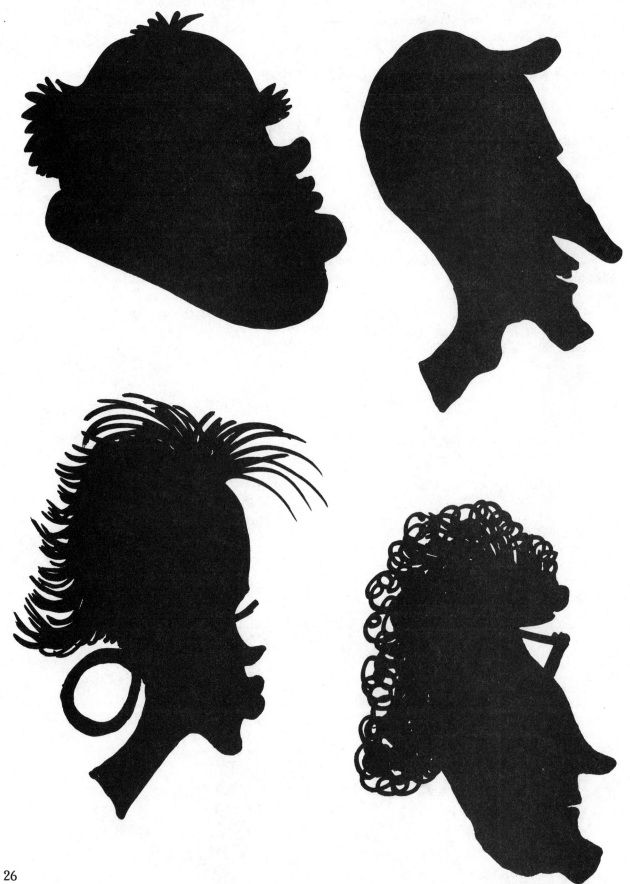

# CARICATURE

Let's tackle a few caricatures beginning with the head shape. This works with overweight people, those with round faces, and those fortunate types who never have to diet (how I envy them)—the very thin—and people who have decidedly square or rectangular shapes to their heads. In other words if the shape of the head is more arresting and significant than the features, try going for it first. If it's a fairly standard heart-shaped or oval face, you might be better served by zeroing in on one of the features to begin with.

Shape and contour alone can communicate personality and identity; caricatures can even be accomplished in silhouette.

Dennis Franz, the Emmy-winning actor from *N.Y.P.D. Blue*, is a natural for a caricature started from a head shape. His features are not all that distinctive (save the slightly Fu Manchu mustache), but he does have an outstandingly strong shape to his head, so once I had nailed that to my satisfaction . . .

. . . I then added the features and, as you can see, flirted with various expressions and attitudes and styles, playing with his cynical eyes with their dark circles, his few wisps of remaining hair, the mustache. And, here, as promised, are several unsuccessful attempts . . .

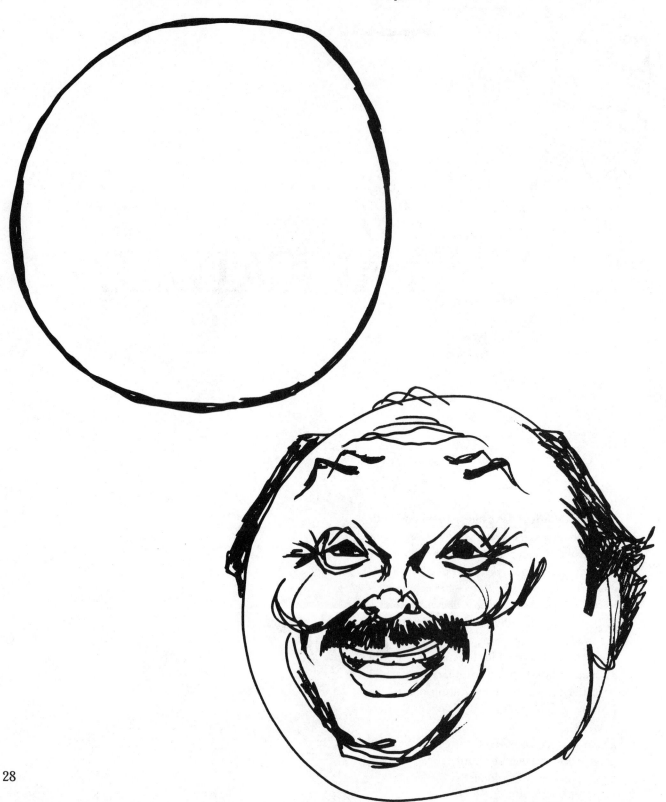

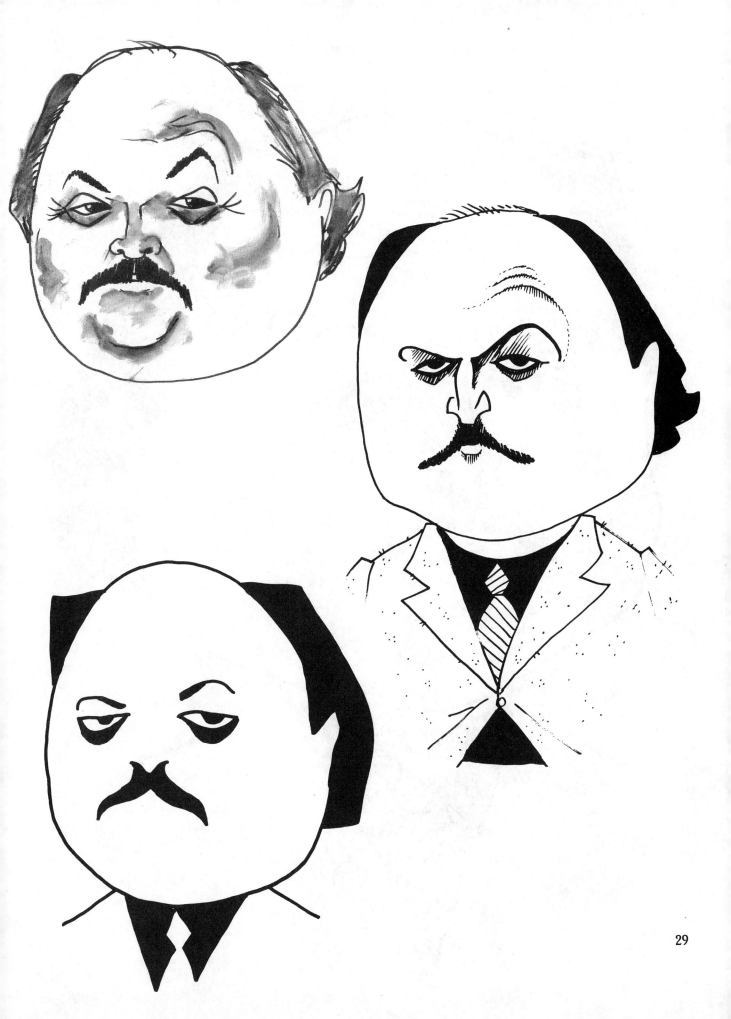

29

Until I finally arrived at the one that worked
for me . . .

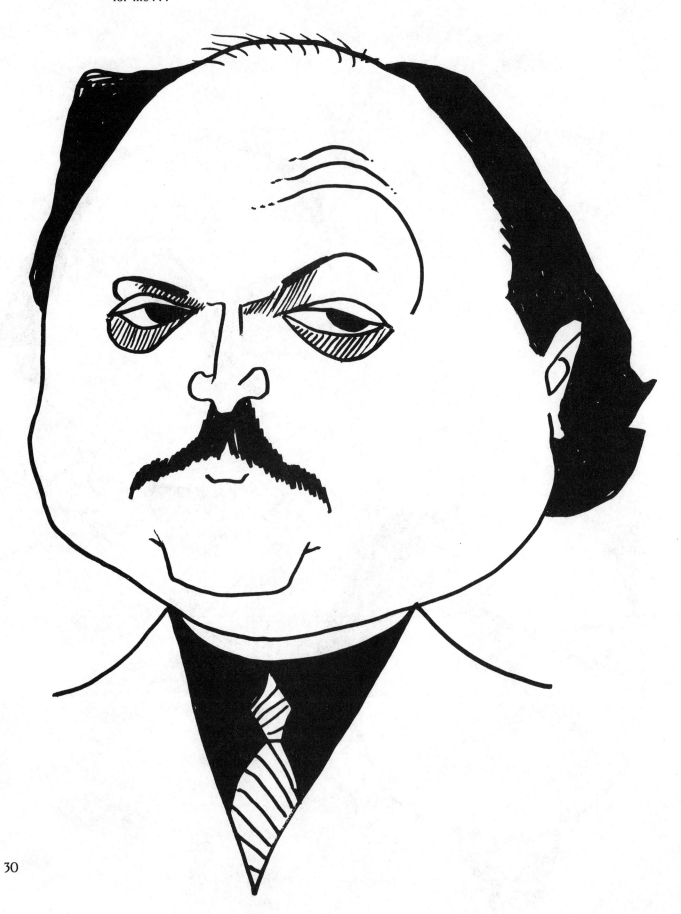

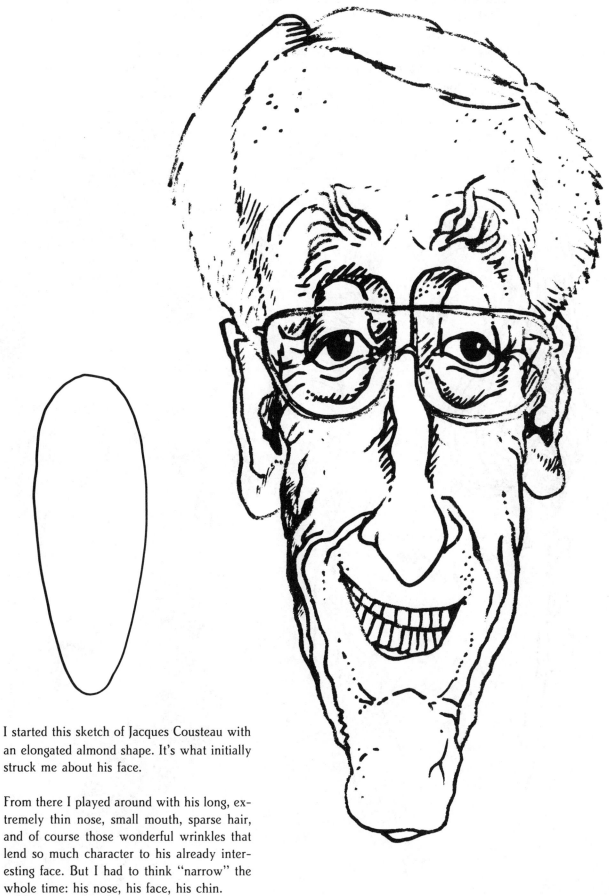

I started this sketch of Jacques Cousteau with an elongated almond shape. It's what initially struck me about his face.

From there I played around with his long, extremely thin nose, small mouth, sparse hair, and of course those wonderful wrinkles that lend so much character to his already interesting face. But I had to think "narrow" the whole time: his nose, his face, his chin.

31

With Conan O'Brien, of late-night TV, his face shape and hair were all there really was to work with; his features are relatively undistinguished. (Sorry, Conan!) I went for the face shape first, again an extended oval, and the extraordinary hair. Once I had these, I then began to place the definitely subdominant features inside the area.

The same applies to Jerry Seinfeld. I started with the elongated head shape. He has a long face to begin with, full lips, and moist, almost Keane haunting eyes (if you remember those very successful paintings of kids from the sixties).

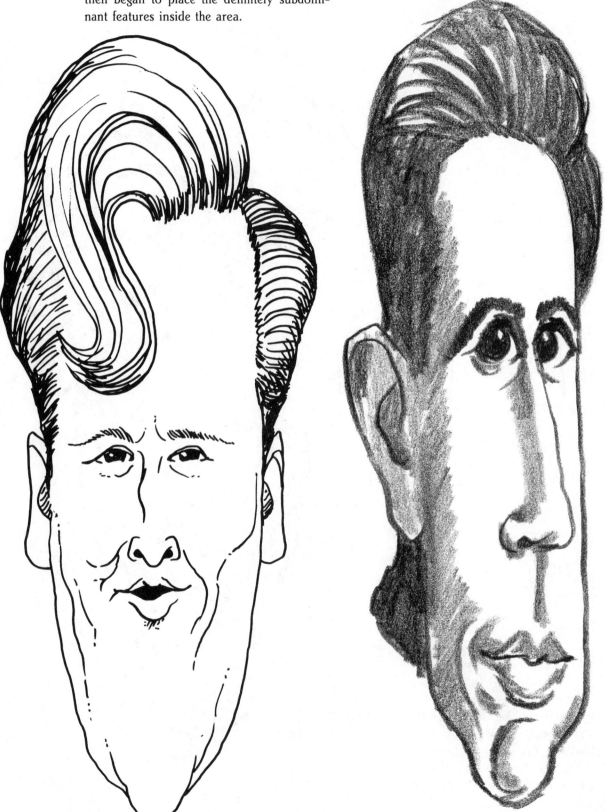

Rush Limbaugh is another "shape first" caricature. His girth and round face cry out to be caricatured. But he's not a circle; he's, as you can see, a perfect pear shape.

He's also a candidate for an ultra-stylized version.

Another head-shape winner is singer Lyle Lovett. Incidentally, I thought he'd be a breeze to caricature, but I was quite wrong. He has a narrow, rectangular face, so I began with the head shape.

But I discovered that he has a very unusual arrangement of nose, mouth, and eyes that doesn't really mesh aesthetically, so I had to play around a great deal with his features before I produced a caricature I could live with.

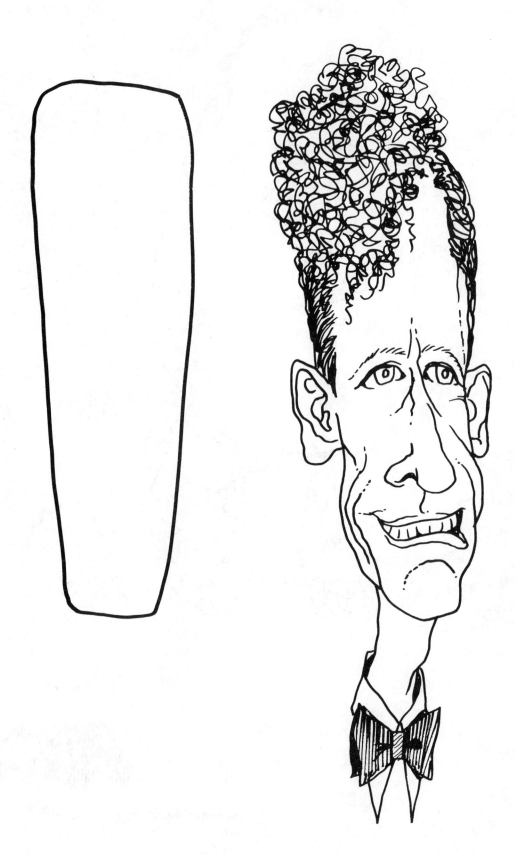

34

Now, moving right along and away from head shapes...Here's a pencil portrait of a woman.

Compare the lines with the ones on her caricature. They've shifted considerably: her gums were lengthened, teeth made smaller, her full-cheeked look accentuated, her already low forehead lowered even more, and her small crinkly eyes are barely wrinkled slits now.

Study the differences here to start to understand how little you have to do in some cases to produce uniform and humorous distortion ...a caricature.

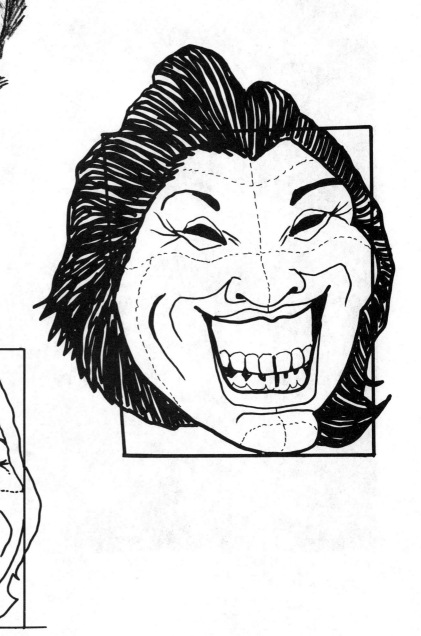

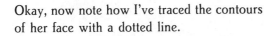

Okay, now note how I've traced the contours of her face with a dotted line.

Jonathan Winters

ACES

On the following pages you will find a series of drawings of friends of mine that will demonstrate to you the process of turning a face into a caricature. Follow me as I either describe what it was about their faces that intrigued me, how I failed miserably in my first attempts (only to pull it from the fire at the eleventh hour), or gradually change their faces from portraits to mild or sometimes even wild caricatures. I'll show you the gradual "corruption" of a face, as it progresses from portrait to caricature.

(Disclaimer time! I must apologize for the quality of some of the photographs of my friends. I modestly claim to be an artist, however I have never, by any stretch of the imagination, claimed to be a photographer . . . and I believe that these examples will bear me out. Nevertheless they do accomplish what I intended: they'll give you an idea of what these people looked like *before* I started playing with and generally screwing up their faces.)

Glenn has a full face and impish eyes, and his full eyebrows are a dominant feature. He also has a slightly flat nose and a short upper lip. The rest of his features, mouth and eyes, are subdominant.

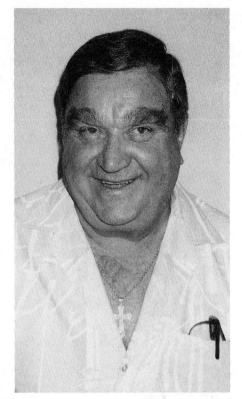

Notice that the line denoting the nose has shifted considerably. I lifted it as I shortened his upper lip and nose. I've brought his eyes closer together and diminished his brow and cranial area while emphasizing his jowls and cheeks by enlarging them.

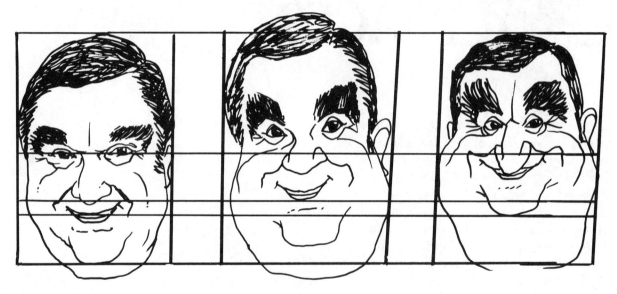

In the final phase I even tucked his mouth
directly under his nose to further accentuate
that short-upper-lip look.

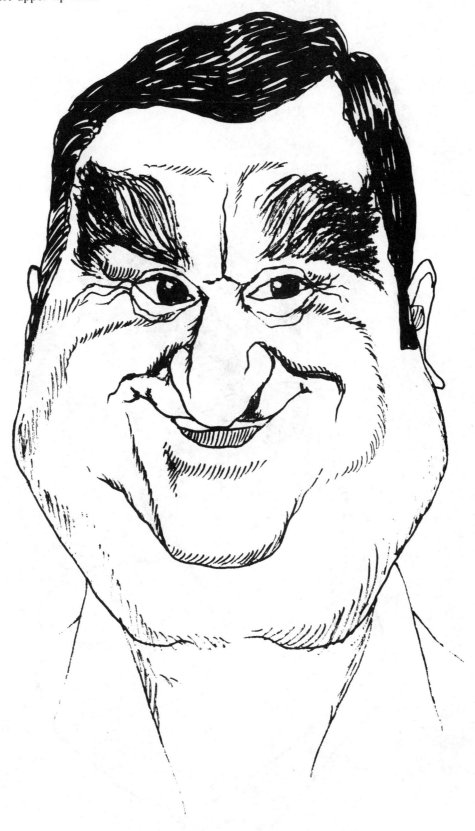

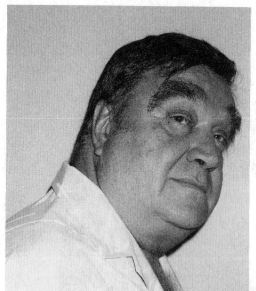

Now, to deal with the choice of angles for a moment, here's a three-quarter view of the same man; you can see why I chose the full-face pose. In the three-quarter view he projects a totally different character; his sweetness is gone, and he appears a little hostile or arch. So you see the choice of angle of the face is an extremely important consideration. It will affect the final outcome in a major way.

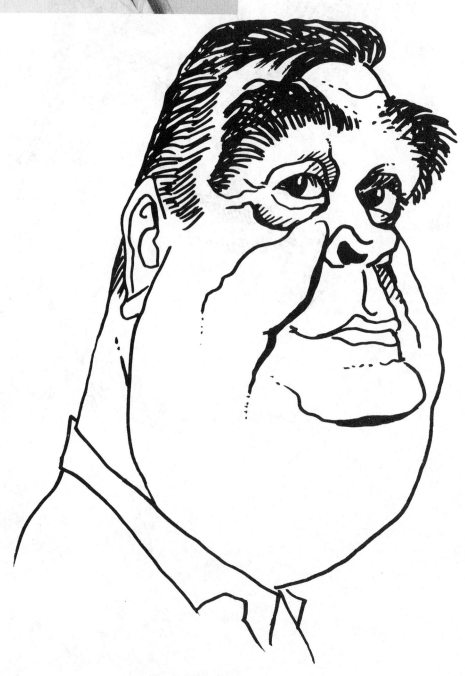

Here's an impressionistic version of Glenn using primarily his head shape and eyebrows, his dominant features.

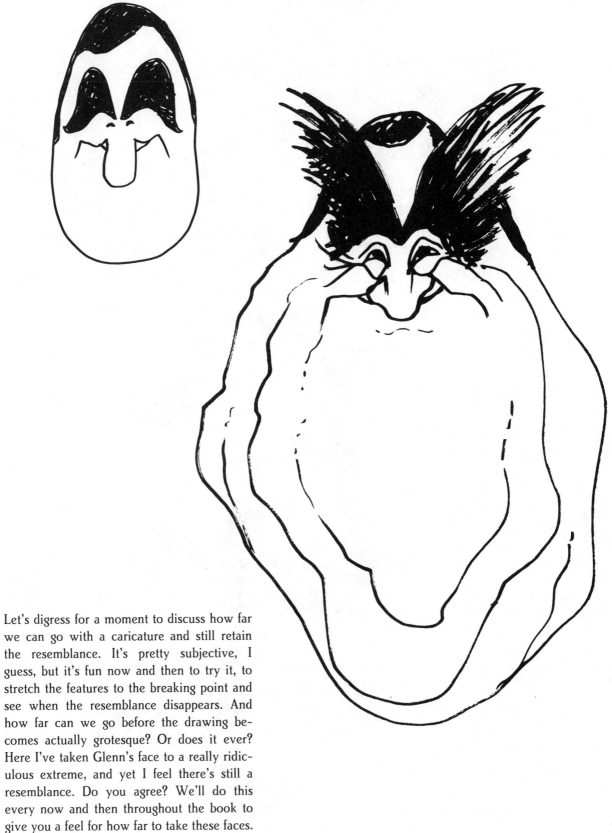

Let's digress for a moment to discuss how far we can go with a caricature and still retain the resemblance. It's pretty subjective, I guess, but it's fun now and then to try it, to stretch the features to the breaking point and see when the resemblance disappears. And how far can we go before the drawing becomes actually grotesque? Or does it ever? Here I've taken Glenn's face to a really ridiculous extreme, and yet I feel there's still a resemblance. Do you agree? We'll do this every now and then throughout the book to give you a feel for how far to take these faces.

41

Jan, obviously, is a large man; we can tell from his neck width and the size of his head.

- A way to communicate "large" or "massive" is to minimize the features within the head shape. But here's a head that can be drawn to the caricaturist's advantage from any angle. It now becomes . . . (here's that nasty word again) a subjective choice. I've done all three, but you try them and see which one appeals to you the most.

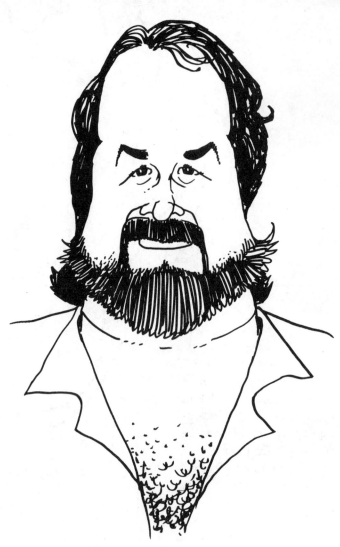

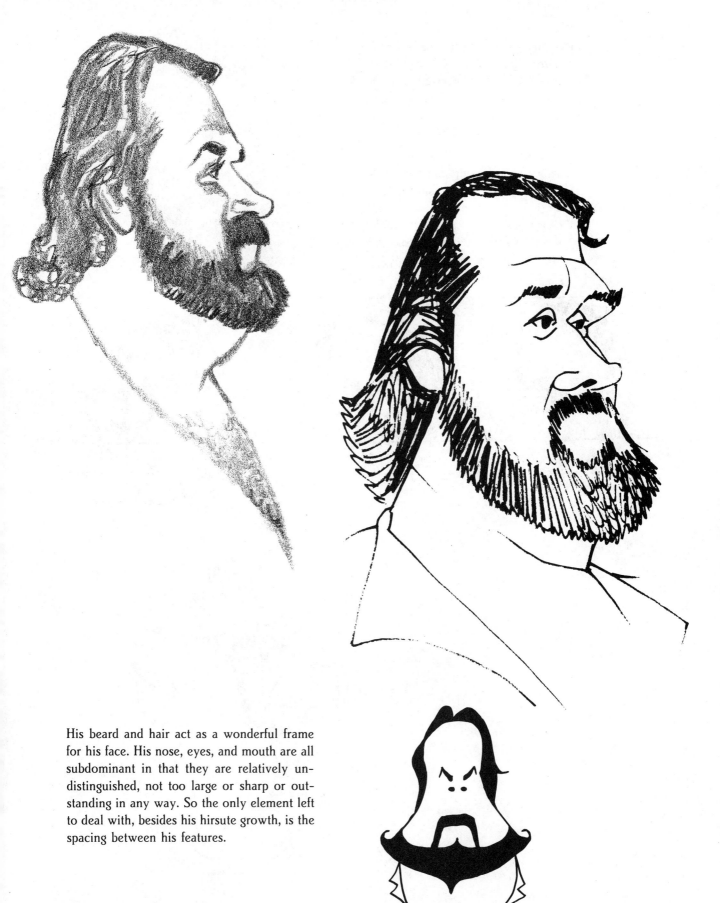

His beard and hair act as a wonderful frame for his face. His nose, eyes, and mouth are all subdominant in that they are relatively undistinguished, not too large or sharp or outstanding in any way. So the only element left to deal with, besides his hirsute growth, is the spacing between his features.

To prove this, here's another caricature just using his dominant elements.

From the massive to the frail—Bob here has a narrow face, thinning hair, and sort of a hangdog look. His glasses dominate his face.

Notice how the measurements change as I lengthen his upper lip and shorten his nose; bring in his eyes and make his head a little more pointy, plus enlarge his glasses. All of the elements have to re-fuse (if there is such a word) in some sort of harmony for a successful caricature.

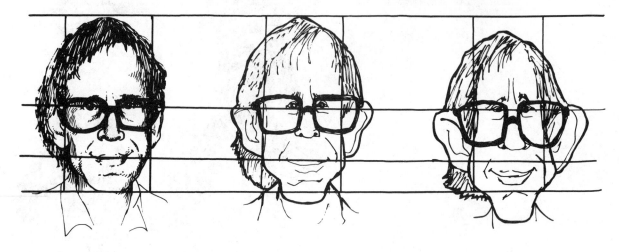

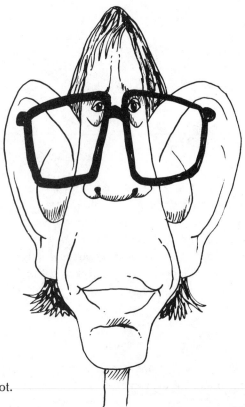

Here's a wilder version of that head-on shot.

And this one was done in that "pencil-ink-smudge" technique that I spoke of earlier.

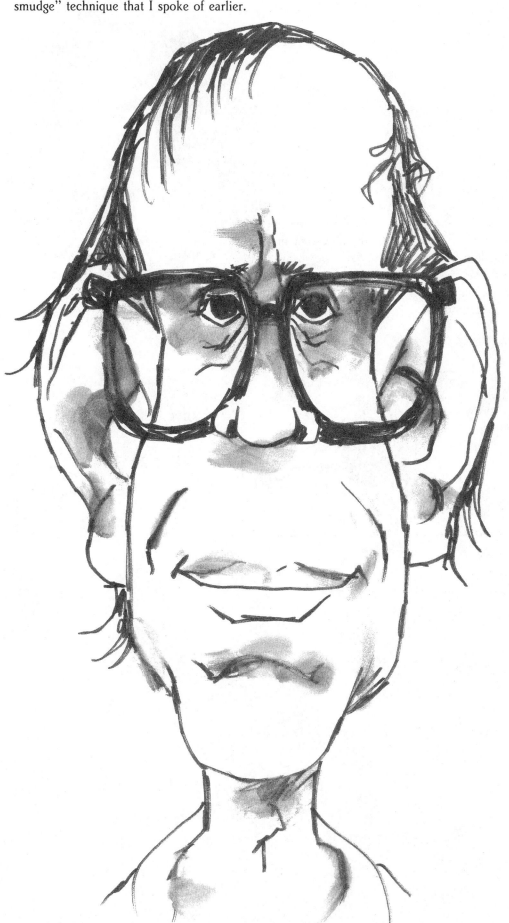

With Bob, unlike other subjects, the profile is nearly as interesting as the front view.

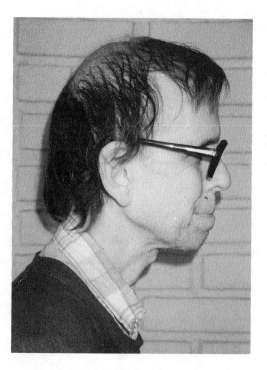

Here you can see I narrowed his neck, squared off his brow and head even more, brought his nose and lower lip out farther, enlarged his glasses, and made his hair even more sparse, especially the thinning area in the back of his head. Plus I shaved down his entire head by about one-third; compare the width of the original portrait with the completed caricature.

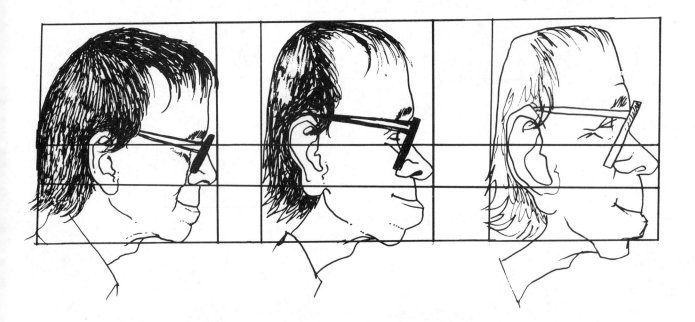

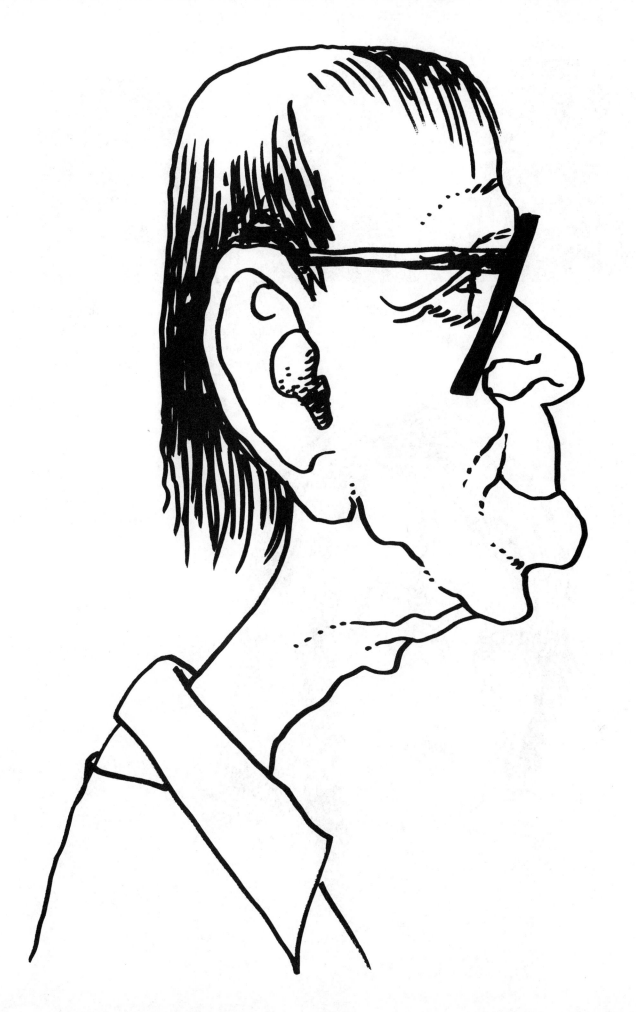

Jimmy, with his wild hair, looks slightly dissimilar in all three shots, so I decided to go for all three versions. My favorite happens to be the three-quarter, but then knowing him personally, I feel that it best represents his quirky personality.

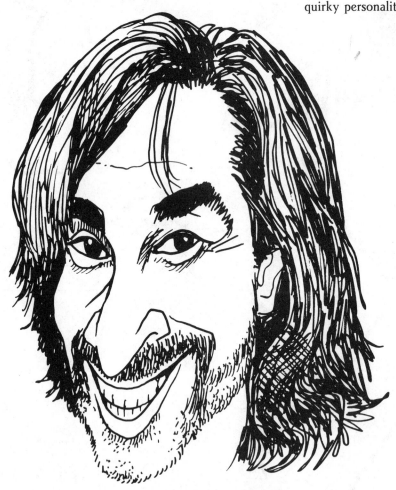

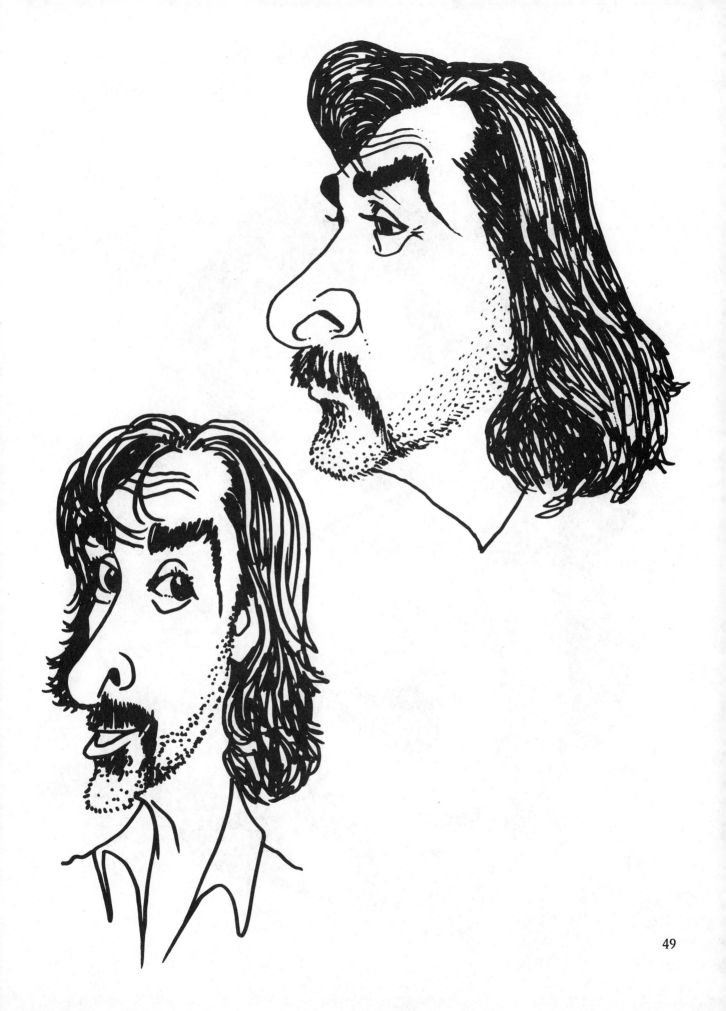

And here's a stylized version of the front view thrown in for good measure. Notice how his sharp features lend themselves to an angular approach.

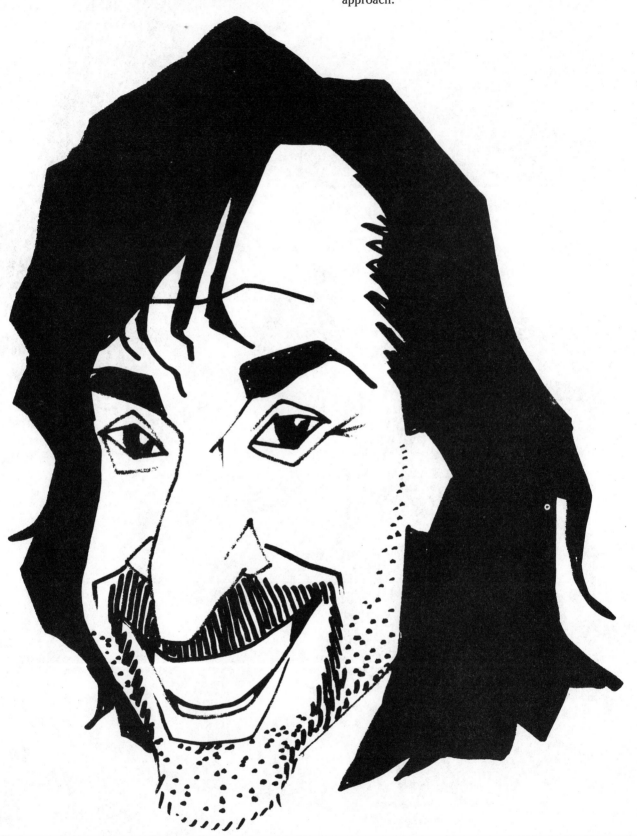

Phil has very even features, so the only things that I could really hang my caricaturist's hat on were his wide, full face, ultra-neat white hair, and obviously, the glasses. But here's another good example of a face shape being crucial to the final drawing. Once I felt that I had his face shape, I felt confident with the rest. The nose and mouth, and even the eyes, are definitely subdominant, wouldn't you say?

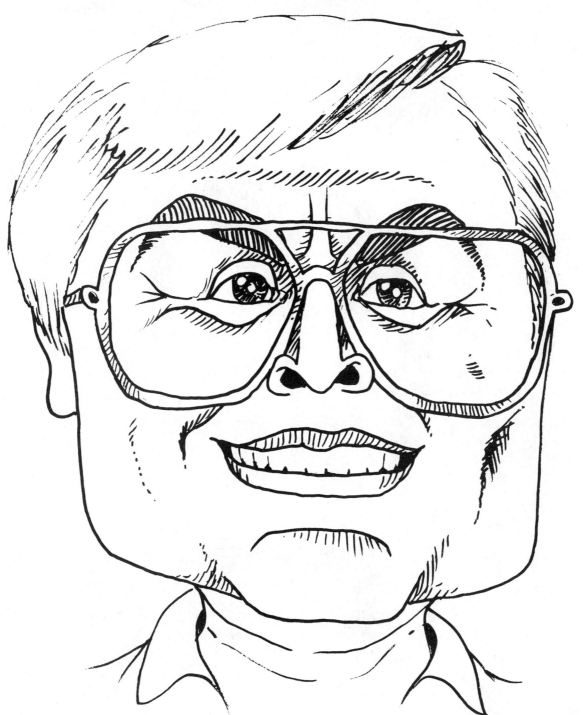

Hal has a very good face to do. The beard frames it very nicely, first of all, but his wide nose, lively eyes, full lower lip, and thinning hair help a great deal. And again, here's a face that lends itself to a stylish, oversimplified technique. Try doing an ultra-simple version of Hal's face.

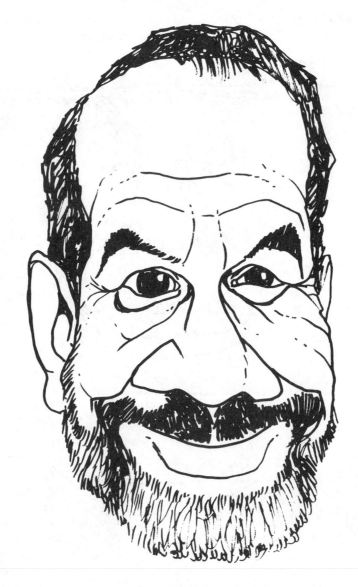

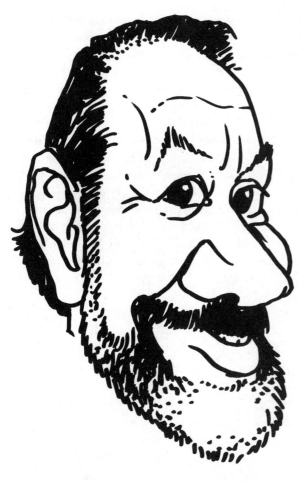

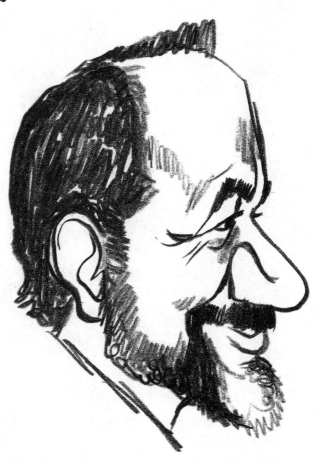

53

Okay . . . I know, I know—I've only dealt with men's faces so far. Well, I did that for a very good reason: they're easier to do. Why? Because for one thing women have softer lines in their faces, smaller, more delicate jawlines and chins (a good way to recognize men in drag is the jawline—it's a dead give-away), and so capturing women in a carica-ture is on occasion a little more difficult. Another factor is that although their makeup makes them more attractive, it also tends to disguise them a little; it smooths out their complexions and makes them all look a bit similar; after all, most women wear lipstick, eyeliner, mascara, etc. And women are given to changing their hairdos not only more dras-tically (again we're dealing in broad brush strokes here, so no accusations of sexism, please!), but more often. Consequently their appearance can alter radically from day to day. So what does the real woman look like? You as the artist have to make that determi-nation. What is her overall, general, usual look? What hairstyle defines her? If she's a professional woman, she might be more tai-lored, a housewife more casual, etc. These various lifestyles are reflected in her makeup, clothing, and attitude, and all of these things should be considered before beginning her caricature. What elements really typify her?

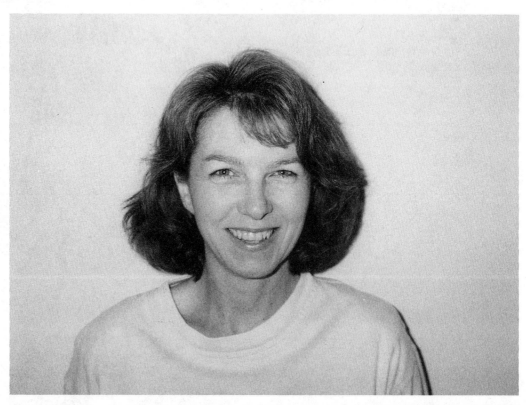

Sue has a sweetness that comes through in her photograph and, I hope, her caricature. There wasn't much to poke fun at here, with the exception of her eyes, which are slightly sad at the outside corners, and her hair. Other than that, she has just pretty regular features.

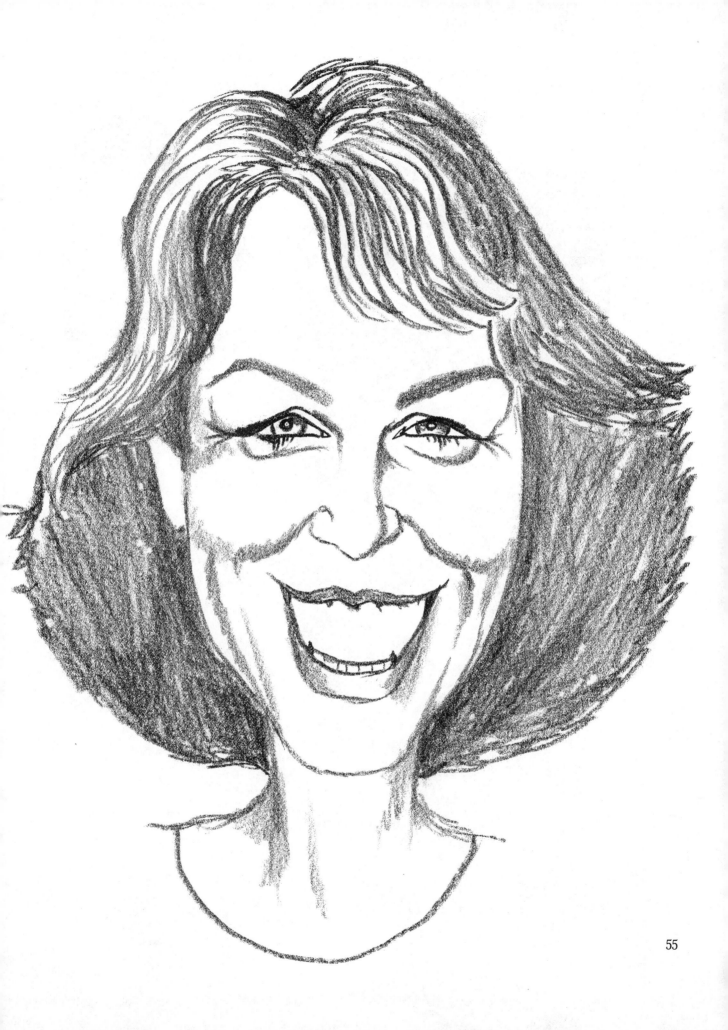

Ann has a warm, unaffected, open attitude, which I tried to express in this drawing.

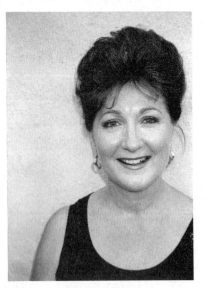

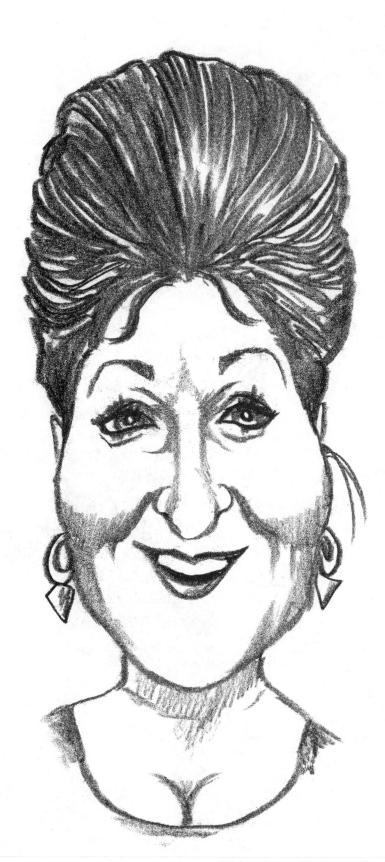

Emily's face projects warmth, wisdom, and a little mischief behind those tinted glasses. This is a round little face with delicate features and extremely neat hair.

Do you see what I mean? There is a softness in women's faces that we have to keep in mind when we decide to distort and turn them into caricatures. I'll keep you apprised of my thoughts as we deal with the remainder of my friends in the following pages. I hope that it will help you to understand the thinking I went through as I was forced to approach each face in a different way.

Also let me add that since women (because of the inordinate pressures put upon them by society) are more sensitive about their looks. I think I tend to be a bit kinder to them than men when it comes to caricature.

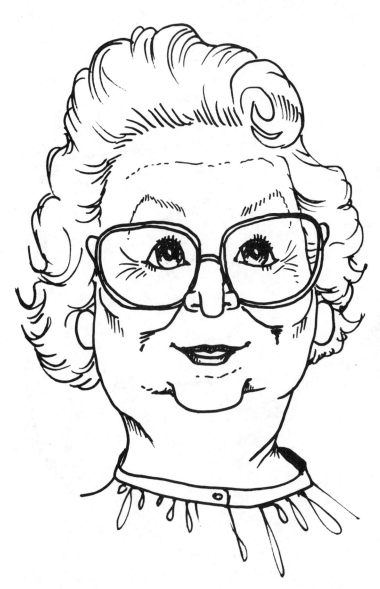

Now, Bob has an irrepressible grin; that with his glasses are definitely the dominant factors, along with his head shape and pulled-down eyes, but his nose is definitely subdominant. Another way to make this judgment for yourself is to sketch the face out and omit what you consider to be the subdominants. Does it still look like the person? Good! Then you've made the right choice. However, if you remove a nose, for instance, and you lose the likeness, you'd better restore that nose—and fast.

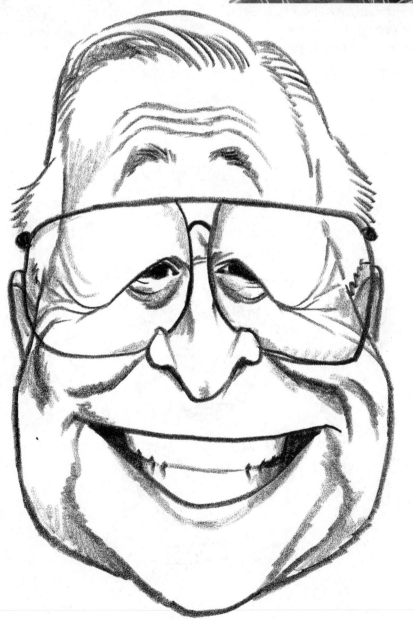

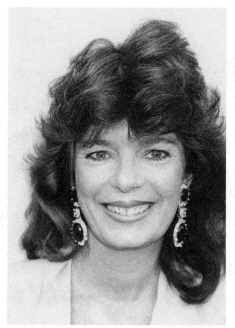

Here's a pretty face with a great shock of hair (red, if we were in color) and an exuberance that must be captured if it's to look like Elizabeth. She doesn't have a lot to deal with from a caricaturist's standpoint: full lips, large eyes, and everything else falls into the category of subtle distortion. Faces like these are sometimes a real problem.

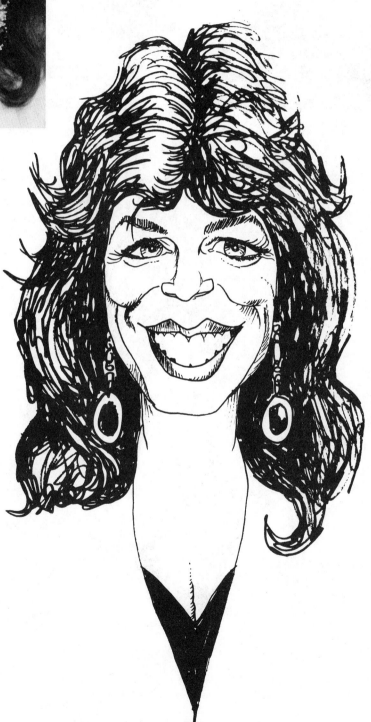

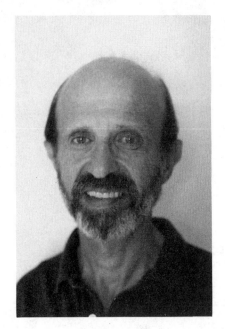 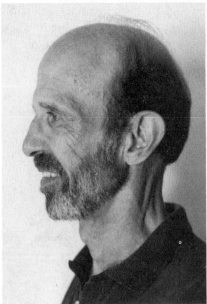 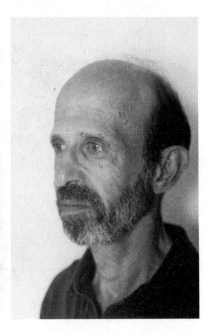

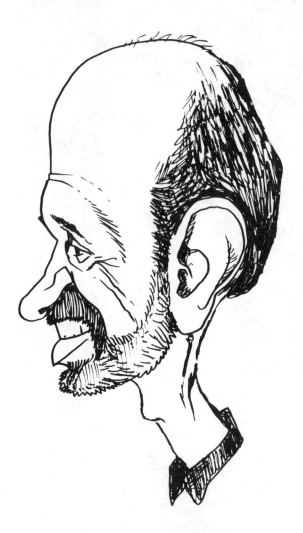

Now Bob here (another Bob? I gotta get some friends with different names) has a most interesting face, and is great fun to caricature. His soulful eyes, balding head, and small chin are wonderful grist for the caricaturist's mill. I chose the front view and the profile, but the three-quarter didn't thrill me, so I passed.

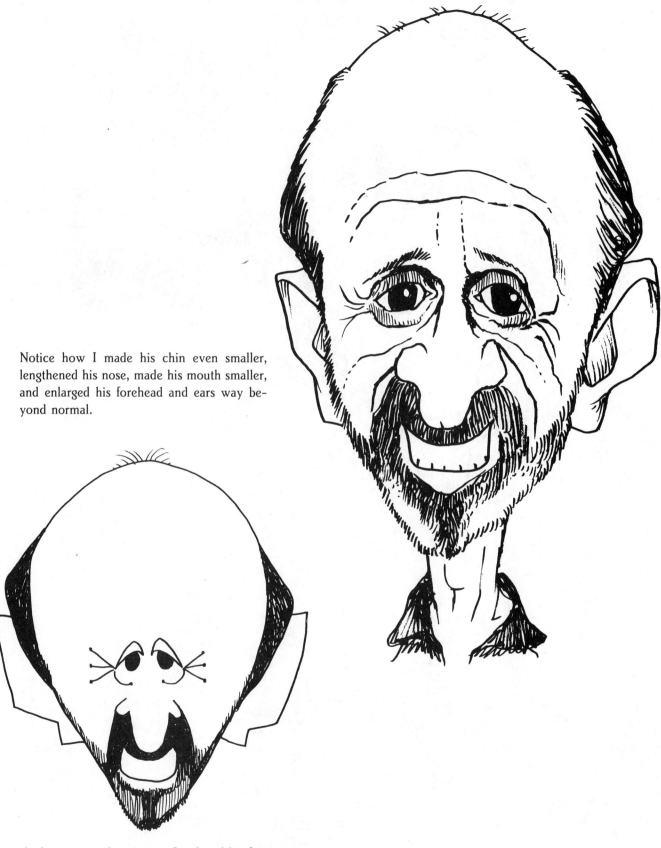

Notice how I made his chin even smaller, lengthened his nose, made his mouth smaller, and enlarged his forehead and ears way beyond normal.

And in yet another version I reduced his features to the very minimum while attempting to maintain a resemblance.

I went for Carol's enthusiasm and wide, in-gratiating smile, her large expressive eyes, short upper lip, and long neck.

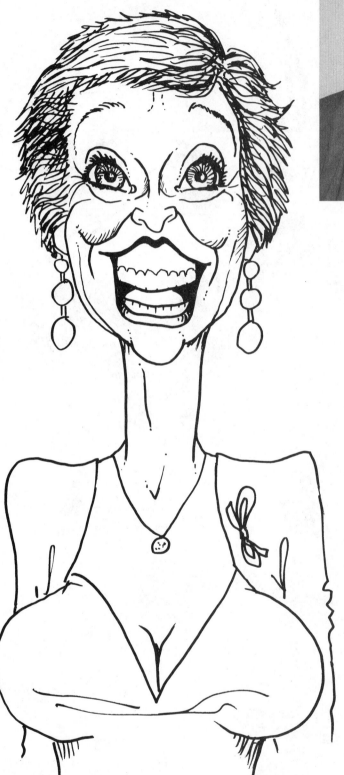

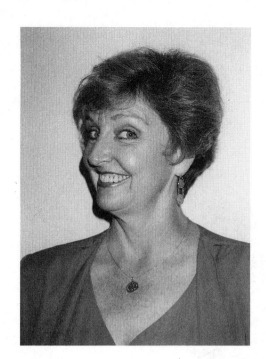

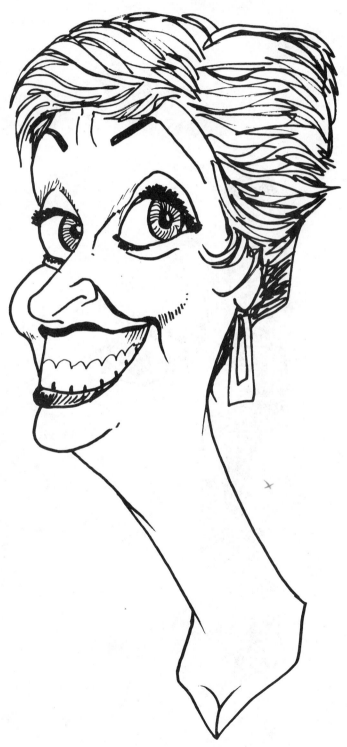

With Herb you can see the vast difference between a three-quarter conveying a pleasant expression and the rather glum front view. How do you wish to characterize this man? What are his dominant and subdominant features? His long hair is a must, but other than that . . . what?

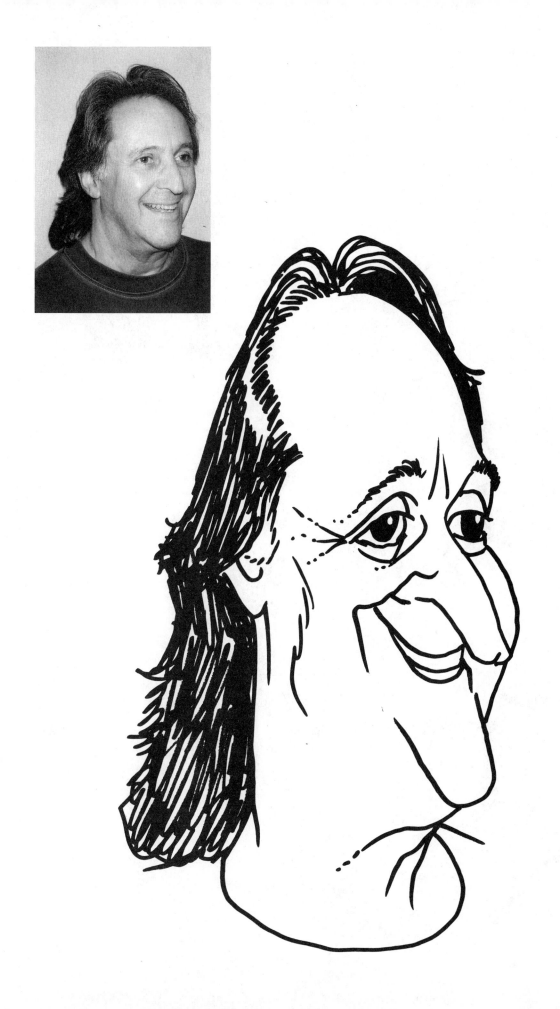

With Patty I stressed her smile, smiling eyes, face shape, and hairdo. Try doing her and keeping her face narrow, or make her nose thinner, and you'll see how quickly the likeness disappears. Sometimes it's a good exercise to attempt a "non-resemblance," that is to say, go the other way from the obvious and see how vital these little things are.

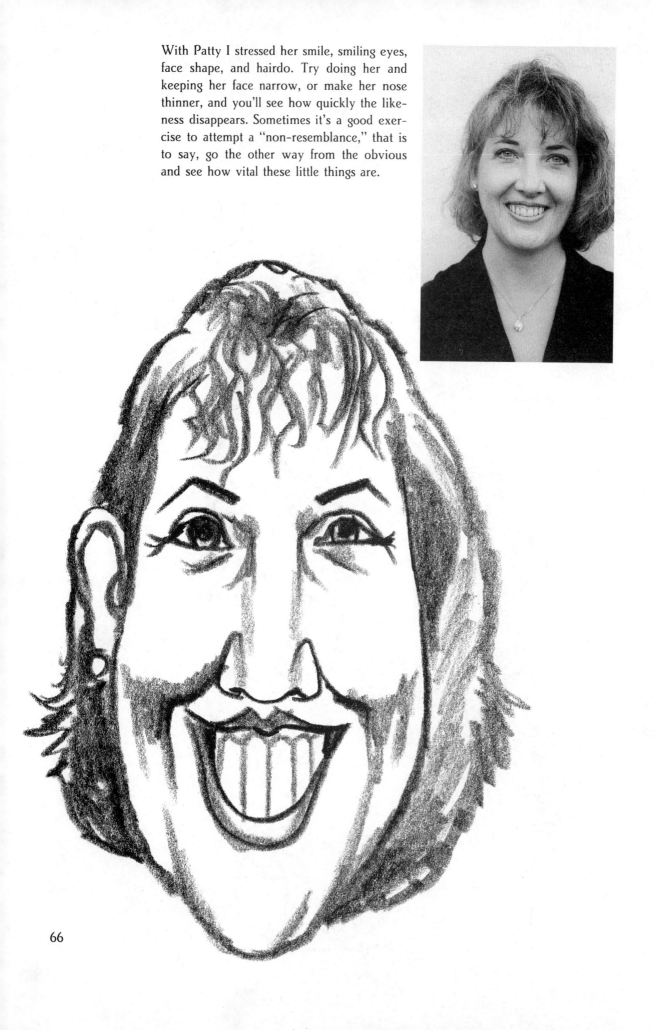

What can we say about Jim's face other than the fact that it's dominated by his interestingly curved nose, large eyes, and his interestingly creased face? He has the look of a man who has tasted life from many plates and learned from the experience. Incidentally, I added the glasses (to his utter dismay) because he usually wears them, and I felt it intensified the resemblance. And I was not kind to those wonderful pouches beneath his eyes. They are probably filled with wisdom.

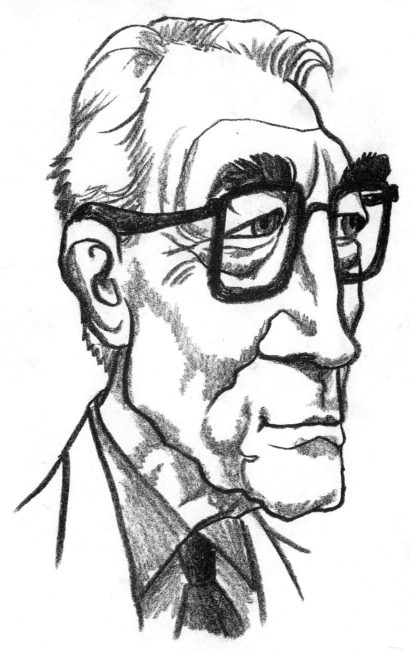

This warm, smiling countenance belongs to Dea. She exudes kindness, but there is not a great deal to attack here. I had to be satisfied with the roundness of her face, her glasses, and her tiny button of a nose. The shape of her hair was worth dealing with, but that was about it. Here's a face where you could omit the nose entirely and it'd still work.

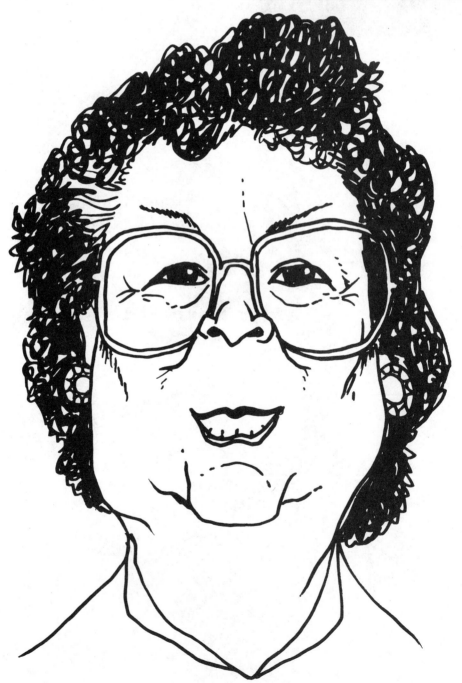

Tony's rugged good looks were fairly easy to capture, but here's a good example of two sides of the face being different. We're all asymmetrical; the sides of our faces are startlingly different sometimes, and it's something of which we must be aware when we're trying to capture a look. That asymmetricality (did I just coin a word?) is a large part of the character of that face.

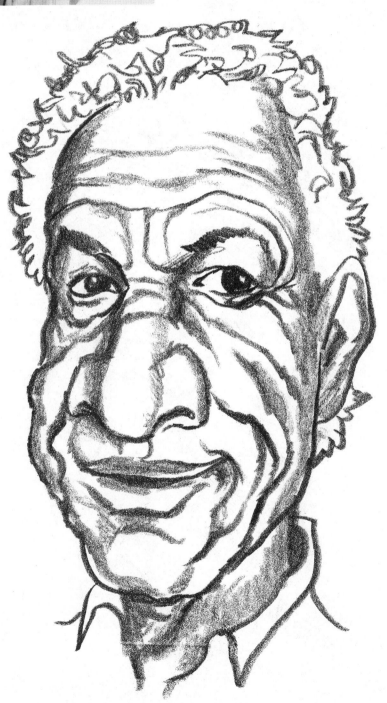

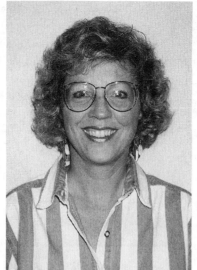
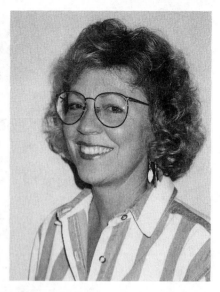

No shortage of things to use in this vivacious woman's face; the glasses, of course, the warm smile, very curly hair, slightly wide nose, and large expressive eyes are all dominant. In fact, Dallas doesn't really have any subdominant features.

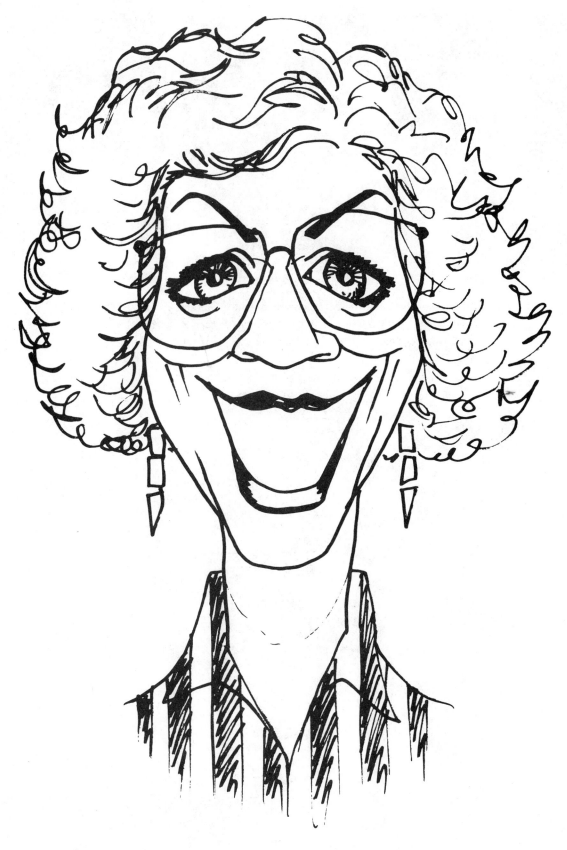

Incidentally, I intentionally included the three-quarter view of Dallas but didn't do her in that angle. Why don't you give this one a try?

All right—what do we see as dominant and subdominant with David's face? Head shape? Yes. Double chin? Getting warm. Glasses? Naturally. Hair? Moderately interesting for caricature. But a key factor in David's face is his fuller-than-normal upper lip.

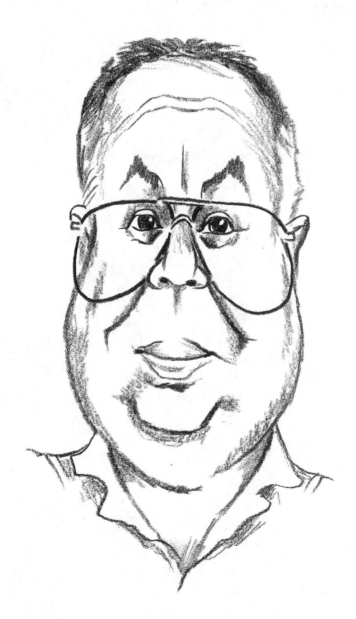

Which of these poses would you choose?
Which do you prefer? And why?

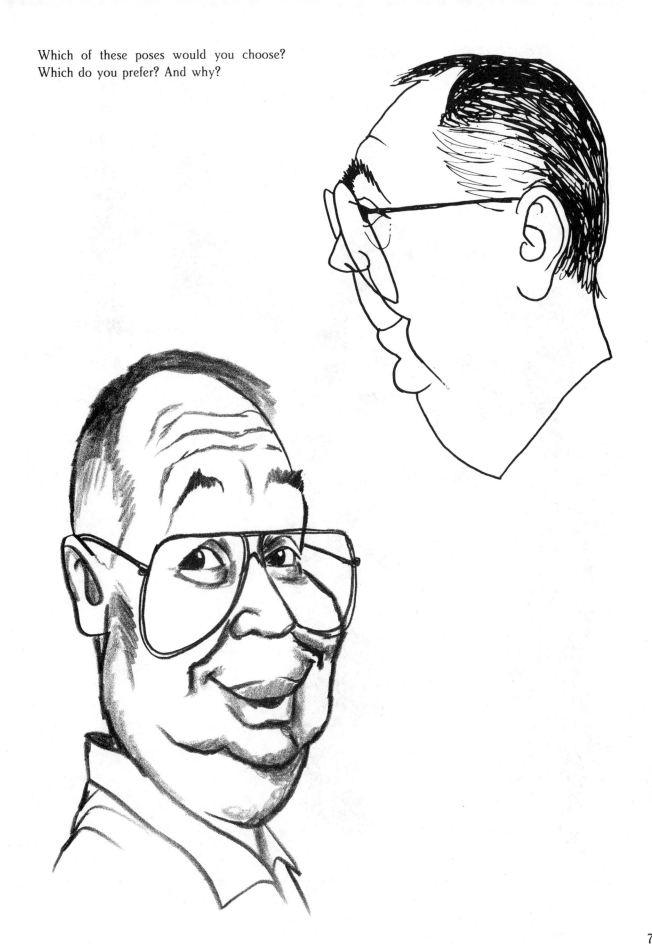

Here's an attractive lady that was not that easy to do. Thank God for Stephanie's braided hair, dark eyes, and dimples, or there would not have been a lot I could latch onto.

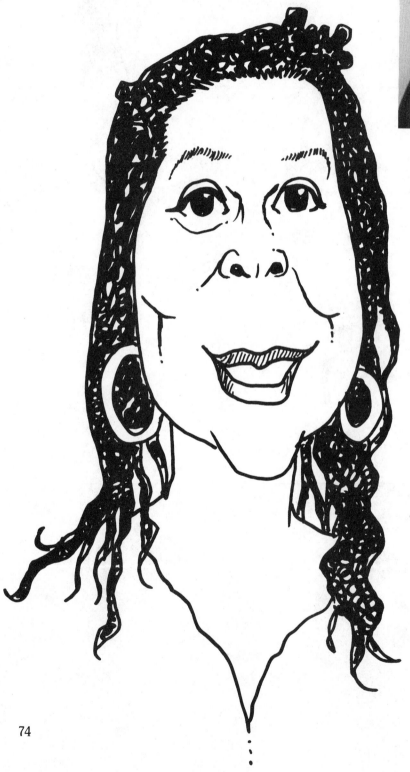

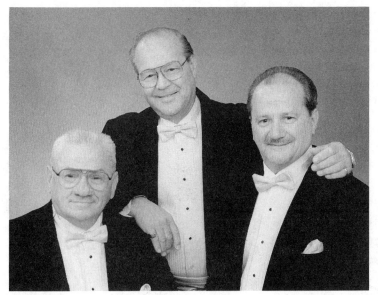

Here's a group of very different looking men, Jim, Vic, and Shag (known internationally as The World's Largest Magic Duo). Going from left to right: Jim has a wonderfully full face with a gray brush haircut and a Karl Malden-esque nose; Vic has a small nose, a sweet, almost boyish face, and a receding hairline; while Shag has a rather long bridge to his nose, a silent-movie-comic mustache, and a very high forehead, with a distinctive, almost squarish growth pattern to his remaining hair. It was fun to caricature these three; they possess such distinctive qualities.

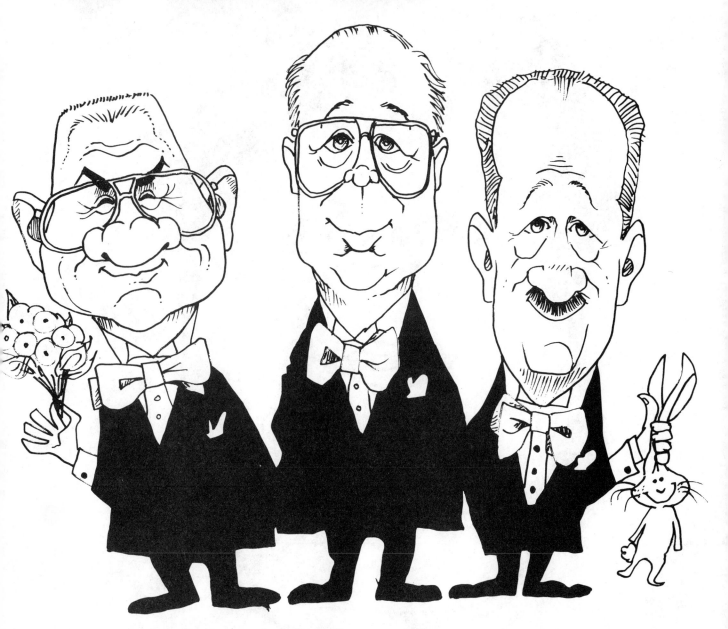

Lupe has a round little face, a nice smile, and pleasantly arranged features. Her head shape is number one on your list of priorities, but other than that you have her small nose and wide-set eyes. That's about it, so concentrate on the relationships (the spaces) between the features.

Sandy has an open smile, bright almond-shaped eyes, a distinctive nose, and lots of freckles, which I'd have been stupid to ignore . . . so I didn't.

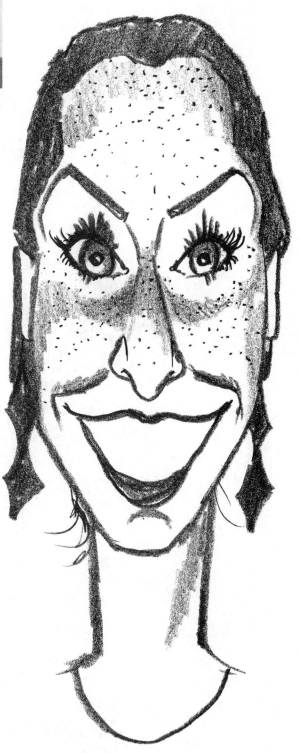

Here's John, who at first glance seems to have a rather average face, but let's look a little closer: long upper lip with a squarish salt-and-pepper mustache, full face, eyebrows that flare up wildly, and a unique hairline with curly hair...not to mention the tinted glasses. And I happen to know that John pursues beekeeping as an avocation, so I chose to picture him involved in that activity. (A little later we'll discuss the additions of bodies to caricatures; this is, in effect, just a teaser.)

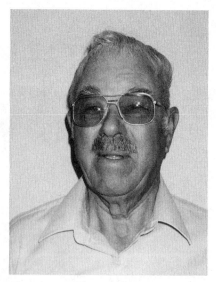

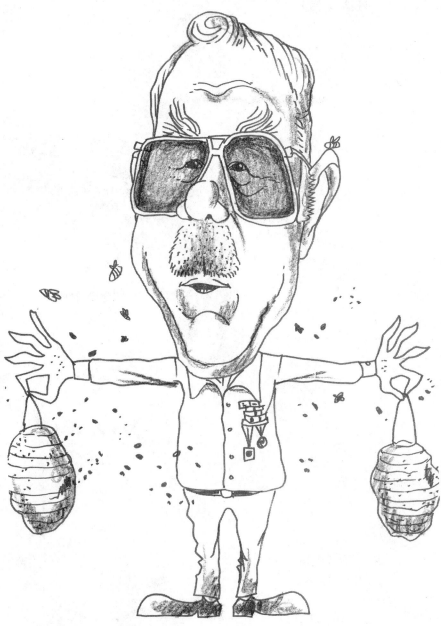

By the way, people bug me from time to time regarding doing a caricature of myself—usually accompanied with smart remarks such as "You're always making fun of other people; how about making fun of your own self for a change!" In response to those vindictive folks, I'm including a "portrait charge" of myself plus a caricature and an impressionistic rendering. I hope this satisfies those of you who have been lusting after my self-ridicule.

What I did with my face was to accentuate my full cheeks (which get fuller every year, I might add), my small deep-set eyes, prominent eyebrows, full mouth, fairly low forehead, and lots of black hair, with plenty of gray creeping into the temples (even as we speak). My nose is the only subdominant thing on my face, but I'm working on it.

There! I hope you're satisfied!

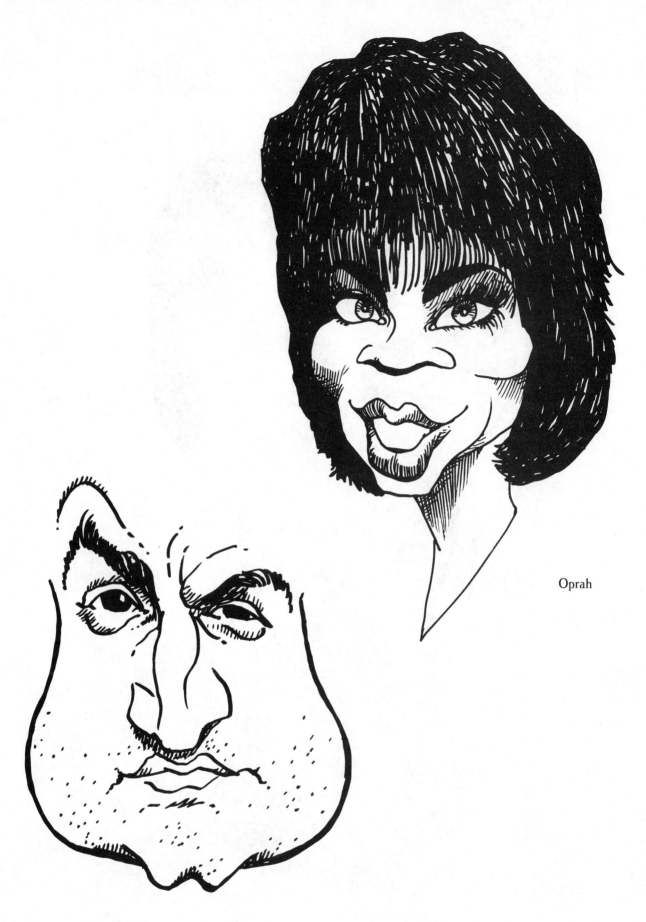

Oprah

John Belushi

# CELEBRITIES

Okay now, watch out *National Enquirer,* we're going to take on some celebrity faces: actors, politicians, sports figures, world leaders, and other recognizable people from the news. At times, caricaturing a celebrity face is easy because the face is so well known to the public that artists are able to use sort of a visual shorthand, utilizing the "symbols" that have become associated with that particular celebrity. On the other hand, if the celebrity has been done too often, we might want to look for an original slant in capturing him or her. Plus, obviously, these people are probably not going to agree to pose for us, and (unless we know them personally) we are forced to use photographs as references, so it's our job to acquire several photographs for each celebrity that we're going to attack. (I'm sorry! Portray humorously.) I'd advise you to begin amassing a collection of photographs, all sorts, all poses, from any source you can find. Tabloids like the *Enquirer* and the *Star* are rich sources for pictures of current celeb-rities; those busy photojournalists (or paparazzi) provide terrific fodder for our needs. I used literally hundreds of reference photographs for the work I did in this book.

The reason I suggest that you use many photographs of a single subject is that one usually doesn't do the job. Try to cull your finished sketch from multiple photos, utilizing a combination: an expression from here, a hairdo from there, an outfit from there. Of course now and again you might stumble upon one picture that says it all for your purposes, but my experience has taught me that that's pretty rare. Don't be satisfied with that one conveniently acquired pose—dig around those used magazine stores or search through the "Biography Series" in your local library; it contains many pictures of international personages that are quite good. So leave no reference stone unturned; ultimately it'll be well worth your time and effort.

Incidentally, I recently purchased a moderately priced automatic camera that has a special TV setting on it, and I was amazed at how well these pictures came out taken right off the tube. I snapped Tom Snyder, Fidel Castro, President Clinton, Daniel Moynihan, Robert Dole, Susan Sarandon, Letterman, Conan O'Brien, and many others from live performances on TV for use in this book. It's a godsend for the artist; with this device you are able to catch the celebrities at their relaxed best, and take as many shots as you wish. It's the next best thing to having them sit for you personally.

Anyhow I must confess that I don't agree with a lot of my fellow artists, who prefer to have their subjects sit for them in person. I don't, the reason being that I feel that the subject can seduce the artist with his or her personal charms, and it could affect your work by causing you to inadvertently lose that valuable objectivity.

Now let's tackle these celeb faces one at a time, and I'll take you through some of my thoughts regarding the capturing of their likenesses (and some of my initial unsuccessful sketches).

Jay Leno has been caricatured a great deal of late, and his long chin has become legend. (It's even found its way into a current joke: "Hey, Jay, why the long face?") But that's not all there is to work on with Jay's face: his rapidly graying, sometimes wild hair is also a standout feature, as are his small mouth, close-set, heavy-lidded eyes, and his slightly flat nose. All of these elements must fuse into a coherent whole in order to get a decent likeness.

In this first sketch I made his upper lip too long, so rather than redrawing it, I merely drew another mouth higher up, toward his nose. Place your finger over the mouths one at a time and see which one helps the likeness. I settled on the one closest to his nose and then went for the new drawing. This is a terrific way to settle on the placement of features in the sketch phase: draw multiple features and block them out until you find the proper placement. It's a great time-saving device.

And here's a very simple approach to this most interesting and well-known face, where I omitted his nose entirely and relied almost totally upon the face shape (accenting that undeniable chin, of course), the hair, and the mouth.

85

Moving right along with TV hosts, Dave Letterman is not as easy to do as I had imagined. Besides the gap-toothed smile, there is his flat nose, but other than that his eyes and hair and face shape are fairly standard. I failed several times prior to arriving at my final sketch. His eyes turn down slightly at the outside corners, he has light eyebrows, and his hair has an odd curl to it.

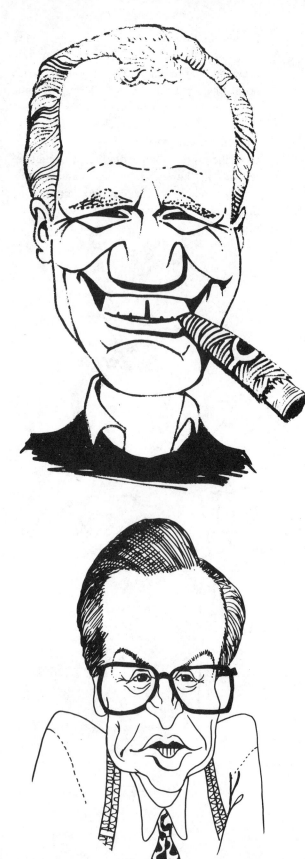

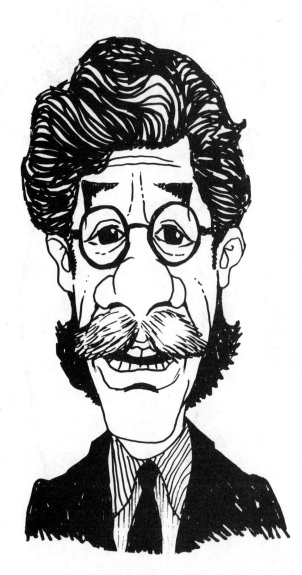

I snapped Geraldo on TV and used several poses before I came up with what I wanted. My first attempts were eminently unsuccessful, but finally I zeroed in on his rather prominent nose (the result of that flying chair?), mustache, glasses, and hair.

As long as we're doing hosts, Larry King's trademark suspenders are a must, and his pompadour hair, high forehead, oversized glasses, and generous mouth are all important elements.

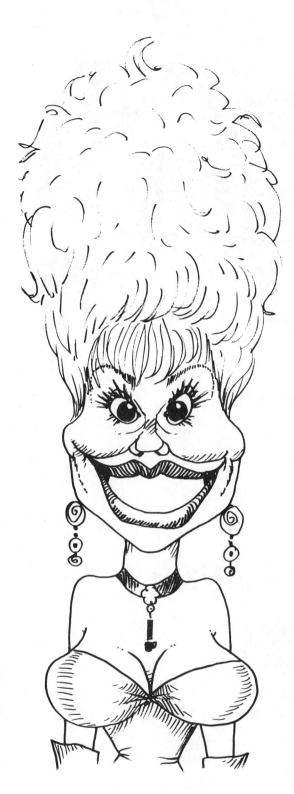

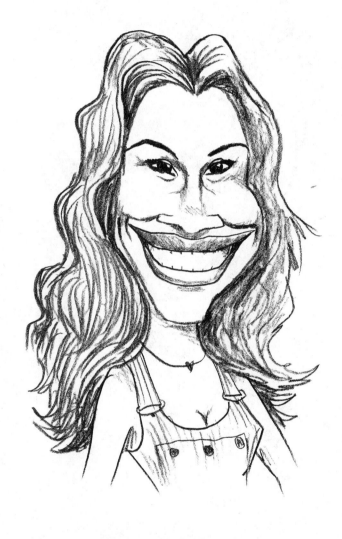

Loni Anderson's features are so even and her face so unlined that there's very little actual character to work with. I focused on her high hairdo, her animated smile, slightly bulbous nose, and of course her figure. And still and all I think she came out looking a lot like "Little Annie Fanny" of *Playboy* fame. But who knows—she could have been the original inspiration.

Here's another *Pretty Woman,* but this one has very distinctive features: a rather large mouth, bright but relatively small eyes, and lots of hair. I found Julia Roberts fairly difficult to capture. She's attractive in an "uneven" way, so one would think that she'd be easy to caricature, but not for me—I went through about forty sketches and finally concentrated on her wide grin, crinkly eyes, and that impressive head of hair. But then no one said this would be easy, did they!

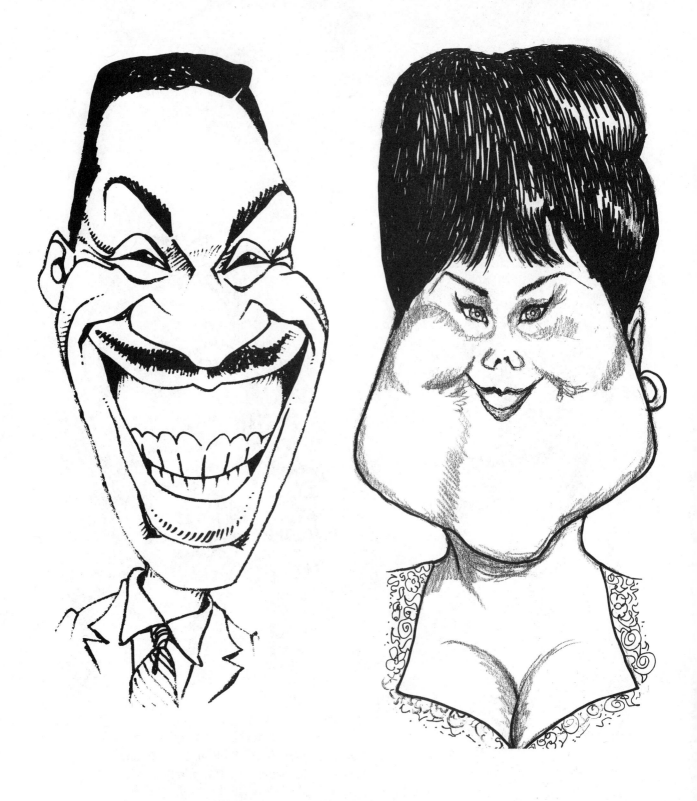

Eddie Murphy was a challenge, and I still feel that this caricature looks older than he really is. It was difficult to combine his youth and his sophistication and still hold onto his likeness. His super-broad grin, small eyes, and distinctive hair are his dominant features. The trick with his smile was to stress lots of gums and tiny teeth.

Delta Burke's girth and mirth are the key factors in this drawing. First of all I used the full-face technique by placing very small features inside a rather large face area. Her raven-black hair is distinctive, in an upsweep, and her eyes are small and slightly almond-shaped.

Drawing Michael Jackson is like drawing a mask; there is so little of his original face left that I feel I'm sketching leftovers. His nose has become an oddly upturned-looking thing, but don't forget his made-up look, with his permanently lined (tattooed) eyes, and that hair that cascades down in front of his large eyes in a semi-messy (yet carefully planned) do. His face shape is also critical, with those cheekbones and the full mouth.

Johnny Cash has interesting hills and valleys on his face, that weathered look that says he's seen life that some of us haven't seen. Pay attention to his black hair, small piercing eyes, and his nose.

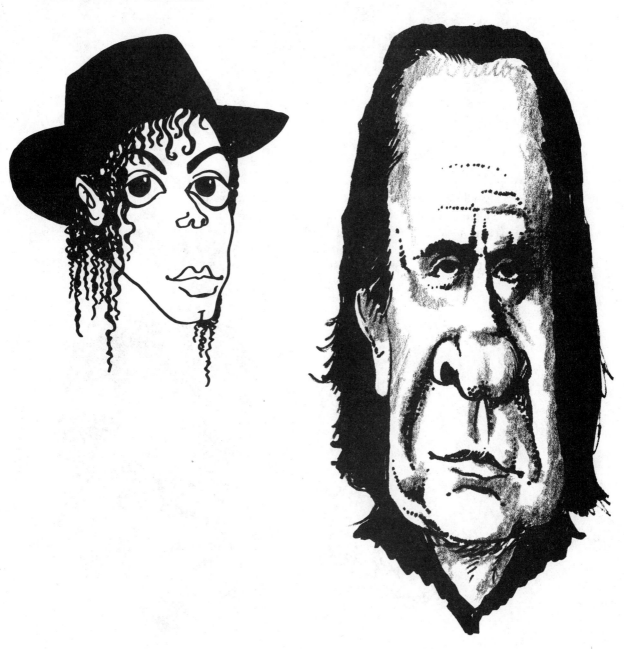

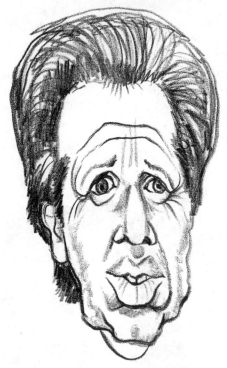

Garry Shandling's wonderful brand of self-deprecating humor comes through (I hope) in this drawing I did of him. He has a terrific face for caricature: worried eyes, full lips (a flaw that he uses to great advantage in his stand-up), and unusual hair.

Rosie Perez has a cute but flawed face: here's a good example of a long upper lip and lots of gums; her crinkly eyes help and her hair is piled up in one of those currently fashionable egg-beater hairdos.

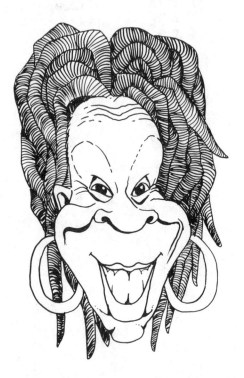

Whoopi Goldberg has many faces: she's a comedienne, an actress of some depth, an emcee, a personality . . . It's hard to pin her down. Again I had a run of unsuccessful attempts, like this definite failure: she looks too young and . . . well, it just doesn't make it. Maybe it was the source material. (Hey, a guy's gotta blame it on something!)

I finally decided on this hairdo (the one for which she's best known) and utilized her wide, ingratiating smile combined with that knowing, no-nonsense expression in her eyes. I feel that I redeemed myself when I came up with this final version of her.

Paul McCartney, the "cute Beatle," has an aging baby face, large, expressive but heavy-lidded, rather sad eyes, a small nose with flaring nostrils, full, pouty mouth, and distinctive hair. What else can you go for?

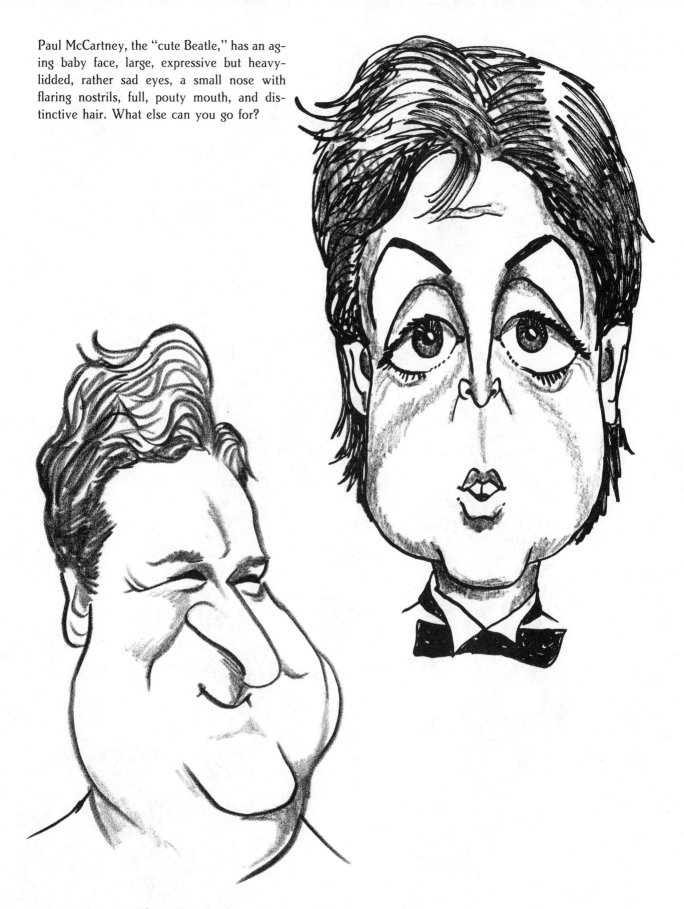

John Goodman from *The Flintstones* and *Roseanne* has a chubby, cheery countenance, squinty eyes, and note the almost perfect pear shape for his head.

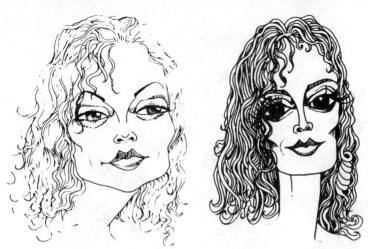

These are two failed drawings of Susan Sarandon, a classically beautiful woman with unusually large eyes. And that's it: the rest of her features are so correct that it made doing a caricature very tricky. She required about twenty sketches prior to the ones you see here. I exaggerated her eyes enormously; they were all I really had to work with. I finally settled on this "portrait charge" of her, followed by a very stylized version of this talented actress.

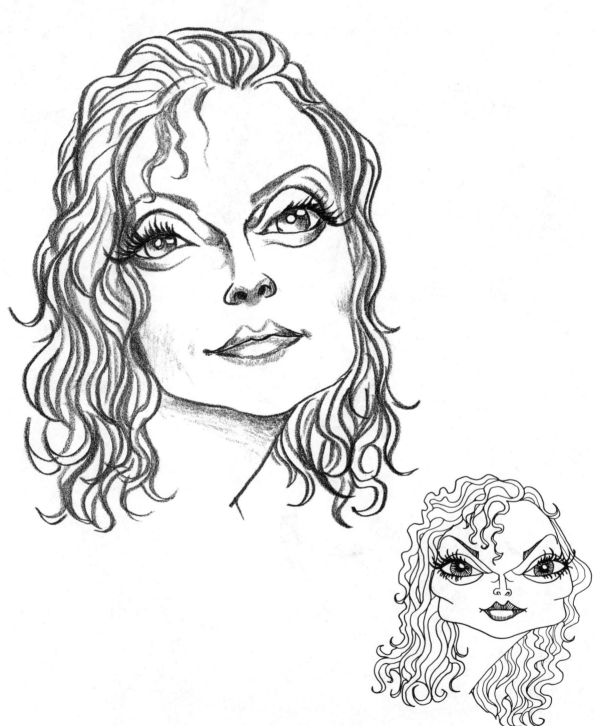

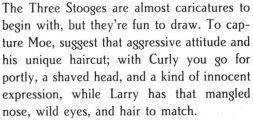

The Three Stooges are almost caricatures to begin with, but they're fun to draw. To capture Moe, suggest that aggressive attitude and his unique haircut; with Curly you go for portly, a shaved head, and a kind of innocent expression, while Larry has that mangled nose, wild eyes, and hair to match.

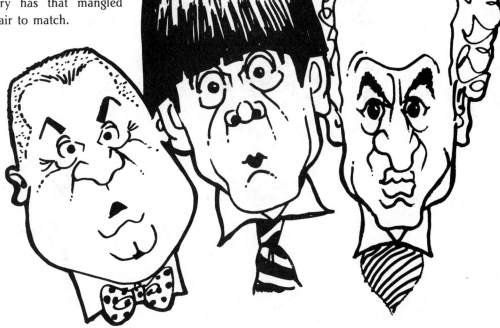

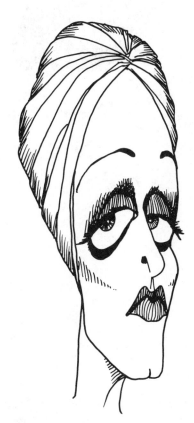

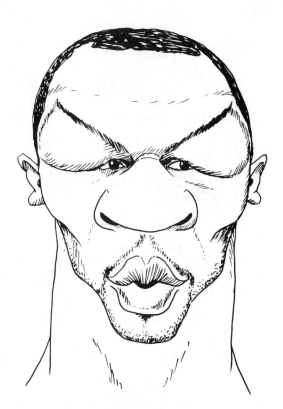

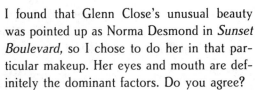

I found that Glenn Close's unusual beauty was pointed up as Norma Desmond in *Sunset Boulevard,* so I chose to do her in that particular makeup. Her eyes and mouth are definitely the dominant factors. Do you agree?

Mike Tyson has some good angles in his face: the extreme lift of his eyebrows work against the lines of his cheekbones for an interesting contrast. I exaggerated the mass of his face and width of his nose, which made his eyes seem smaller.

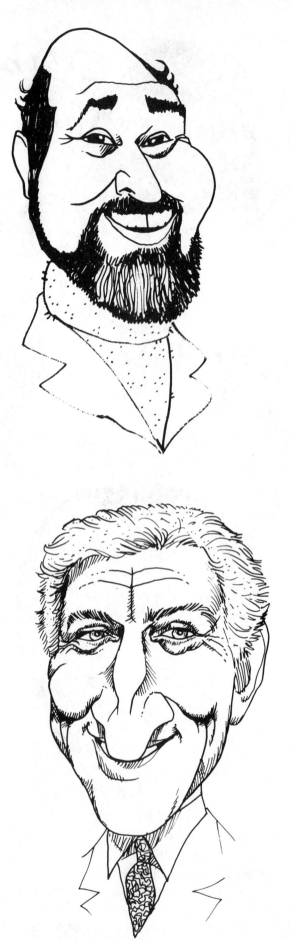

Rob Reiner, now an outstanding film director, looks very different from his days as "Meathead" on *All in the Family*. Now he's certainly easier to caricature. He's allowed himself to mature and gain some weight. Rob has an infectious grin, but the beard and bald head really are the keys.

And here's an example of a treatment wherein I suggested his face impressionistically just by stressing the spatial relationships.

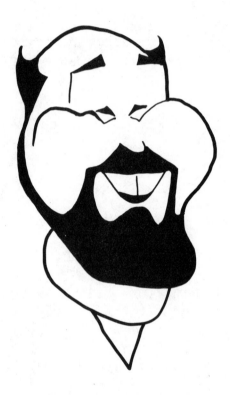

Tony Bennett's dominant feature? The nose. Tough guess. But also we can't forget that warm smile, slightly receding mouth, those expressive eyes, and that shock of gray hair. Tony's quite an artist himself.

I tried to capture Martina Navratilova several times from a series of photographs where she sported a long, soft hairdo. Bad choice. In the second one I made her upper lip too long, and my friends thought I had done Carol Burnett. I subsequently shortened Martina's upper lip, stole her loose "Dutch boy" hairdo from a new reference picture, and improved it. Here are those three versions. Can you see the amendments and the ultimate improvement?

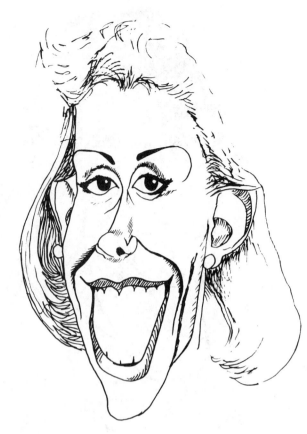

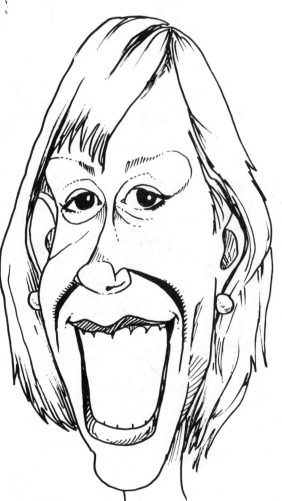

95

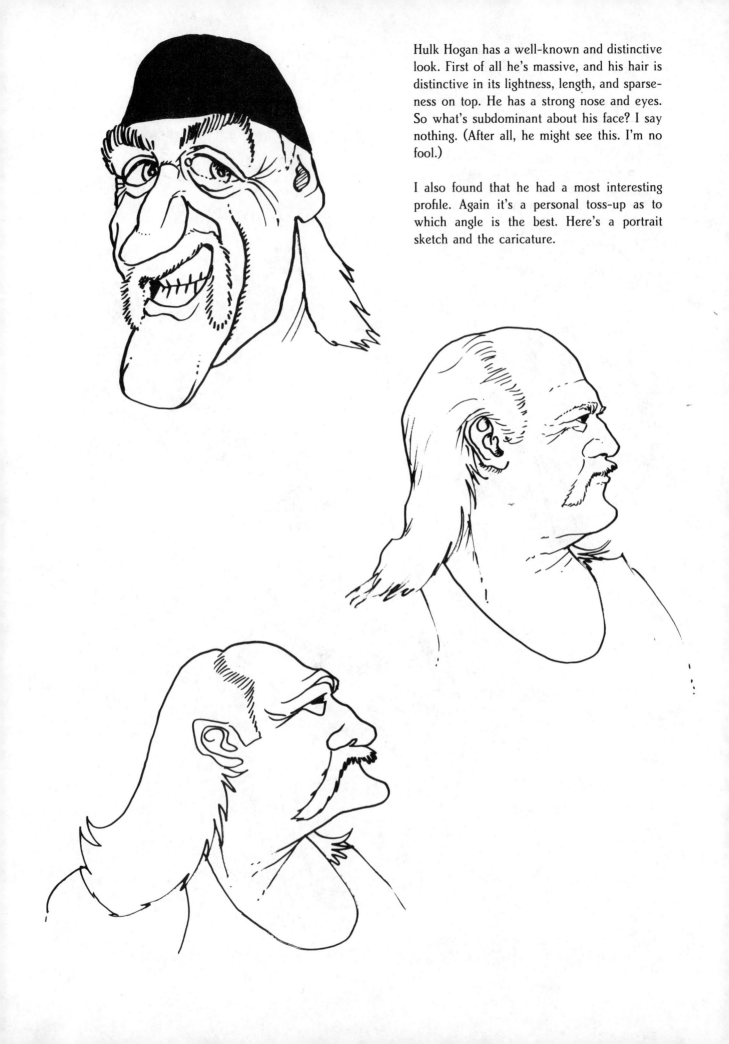

Hulk Hogan has a well-known and distinctive look. First of all he's massive, and his hair is distinctive in its lightness, length, and sparseness on top. He has a strong nose and eyes. So what's subdominant about his face? I say nothing. (After all, he might see this. I'm no fool.)

I also found that he had a most interesting profile. Again it's a personal toss-up as to which angle is the best. Here's a portrait sketch and the caricature.

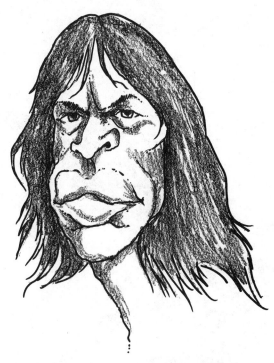

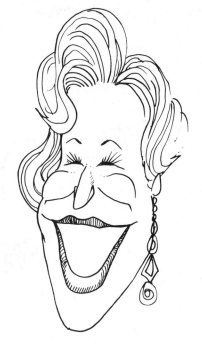

Here's another aging rock 'n' roller, whose trademark oversized lips make him an easy target for caricature. But that's not all: his eyes burn with intensity, his hair cascades down straight and loose, and the leanness of his face is an element not to be ignored.

Bette Midler has a distinctively shaped full face, small but very expressive eyes (which I've chosen to depict merely as merry slits), and a large mouth.

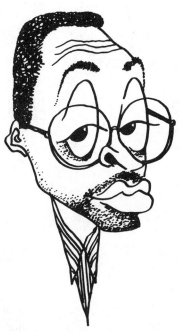

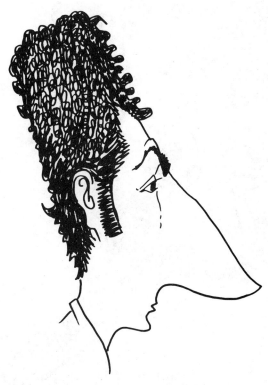

Spike Lee has heavy-lidded, rather contemptuous eyes, a full mouth, and large glasses. To picture him smiling pleasantly would be wrong; it's simply not his public persona. In caricature we are generally trapped into going for the cliché that surrounds the particular personality. Deviate too much from that and you can lose the resemblance.

What a perfect face for a profile caricature: just the nose and hair alone tell the viewer instantly who this is. I accentuated his nose way out of proportion, but I think it works. That and his kinky, curly hair do the job; the other elements are not important contributors. P.S. It's Michael Richards from *Seinfeld*.

97

Here's a stylized profile of Chico Marx, of the Marx Brothers. I chose this profile because I felt that the shape of his hat, his nose, and the curly hair combined for an interesting picture.

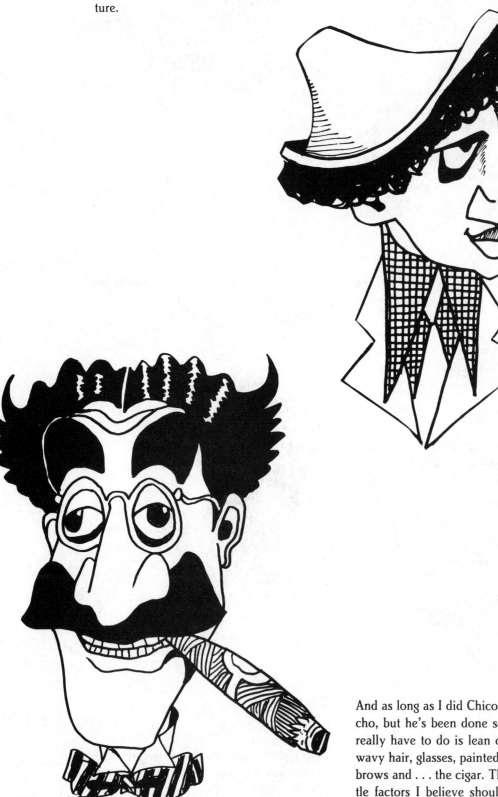

And as long as I did Chico, why not do Groucho, but he's been done so often that all you really have to do is lean on the symbols: the wavy hair, glasses, painted-on mustache, eyebrows and . . . the cigar. There are other, subtle factors I believe should be included, like his prominent nose and that one eye that drifts off a bit. It gives him a slightly nutty look.

These two preliminary sketches of Tom Snyder didn't make it for me; I think I made his face too long. He has a very rectangular head, heavy brows, white hair with a very sharp hairline, a long upper lip, and flaring nostrils.

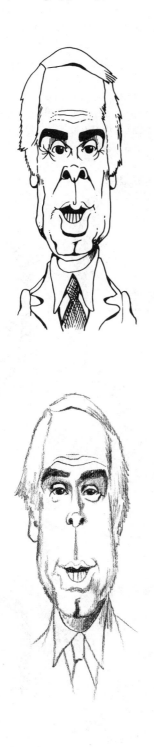

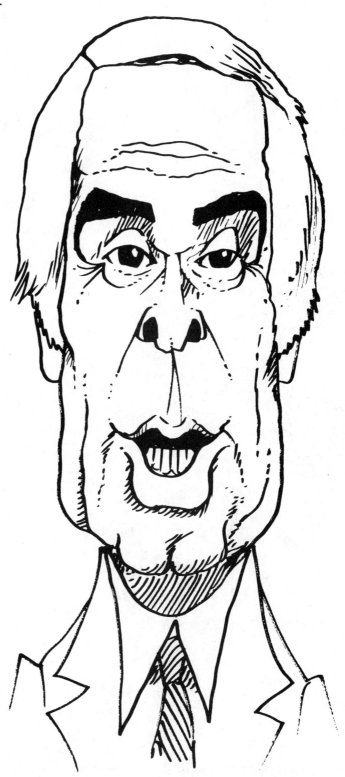

I finally split the difference and came up with this version.

Fabio has a distinctive look. The first thing that struck me was his hair (of course), the enormous width of his jawline, and his tiny eyes. The rest of his features are relatively undistinguished. Fabio is another prime candidate for a very stylized approach.

Here are a couple of vain attempts at capturing Tommy Lee Jones. In the first one the face is too long; it looks a little like John Malkovich (a fine actor but not Tommy Lee). He has a series of interesting planes that make up his well-known face. He has sharp cheekbones, a strong nose with a thin bridge that widens at the tip, and he has small, deep-set eyes and a strong brow. His eyebrows shoot upward and tend to give him a slightly mean look. Finally, after finding a few more photos in some magazines, I came up with a more acceptable version, but this time I resorted to my smearing finger technique.

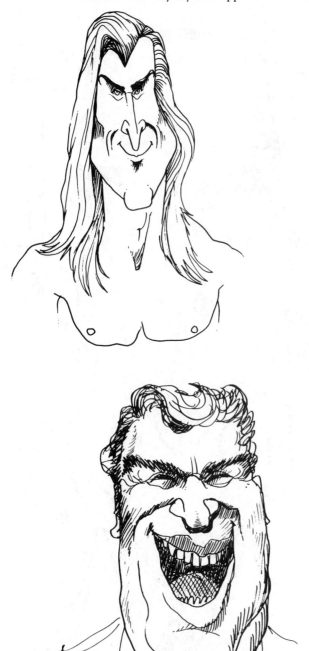

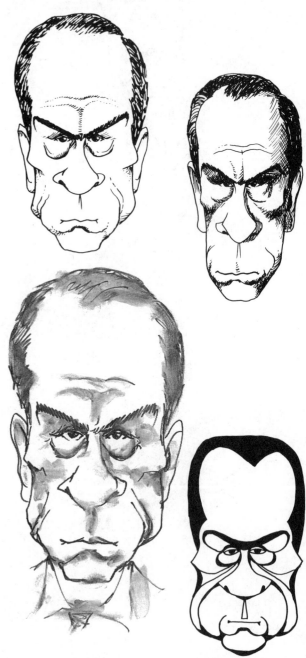

John Madden, of football announcing fame, has a large, rectangular head with squinty eyes and generous (dominant) mouth and nose. His hair, too, is a definite dominant, and his long, slightly separated teeth aid immeasurably in nailing down his resemblance.

And then I decided to do him in an ultra-stylish manner.

Here's another friend and costar from our old *Bye Bye Birdie* days, Dick Van Dyke, a fine caricaturist himself. (I hope he likes this one!) His Stan Laurelish long face, dominant nose, and large eyes are the things on which to focus. Of course I had to add the white hair and mustache. *Très distengué.*

If you tire of show business personalities, the political arena is a rich area to mine; for one thing the cast of characters embrace the globe, and they're not a bunch of pretty people, as are most actors and actresses. The majority of them are a little older, which usually gives more character to their faces, and the ethnic mixture helps in the visual interest department.

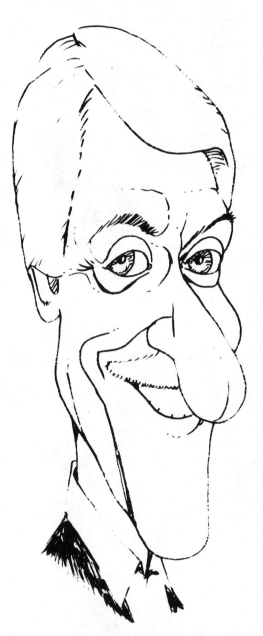

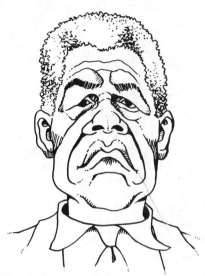

Nelson Mandela, even without any awareness of his background, seems to project sadness; he has a downturned mouth, yet his eyes possess a certain nobility (or maybe I'm just reading that into them). He has gray, short-cropped hair and fascinating creases in his face.

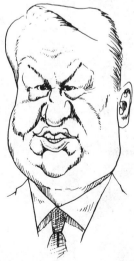

Boris Yeltsin has a rather average face, so you have to find the character in his shock of white hair, small, slightly slanted eyes, full cheeks, and his nose.

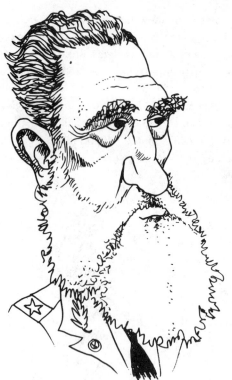

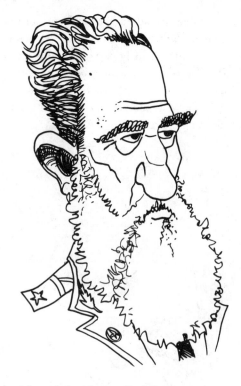

Fidel Castro's countenance has been known to America for over thirty years. The recent photos taken of him reveal an older, grayer version of the man we remember. His nose appears a bit flat (as if it's been broken), his eyebrows are wild, and his eyes intense.

And here I decided to do him just a bit more broadly.

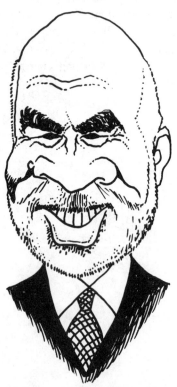

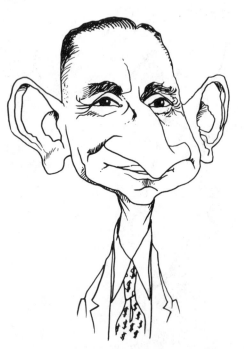

Ross Perot is fun to do. Not only does he have a very distinctive nose, but he has a rather small mouth (odd for such a loquacious chap) and of course those 747 ears and that haircut from the early forties. However, note that in spite of his billions, his eyes are still slightly sad. I guess Mom was right when she said "Money can't buy happiness!"

This ruler has a friendly face; if you didn't know who he was, you could mistake him for the corner grocer. He has a warm smile, a white beard, ethnic nose, and small eyes.

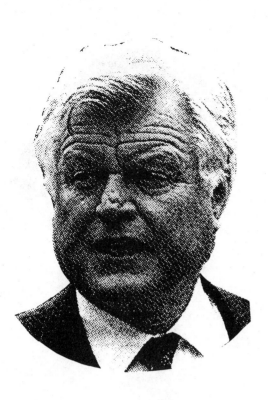

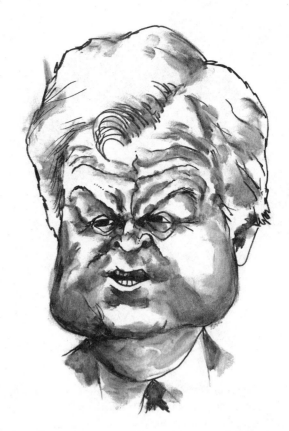

Ted Kennedy has an extremely square face, pronounced jowls, small eyes and nose, and a lot of gray hair.

Here I did him in a milder caricature and then . . . a wilder one.

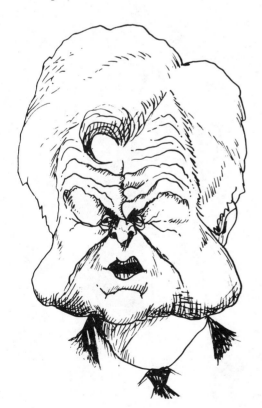

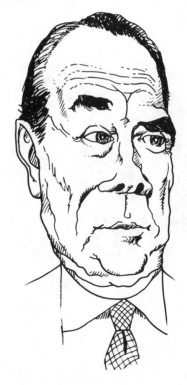

Robert Dole's rather dyspeptic countenance was not terribly hard to capture. He has a craggy face and humorless eyes. And of course how you choose to represent partisan figures depends greatly upon which side of the political spectrum you roost on.

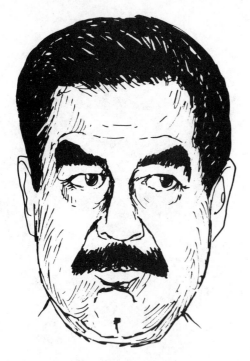

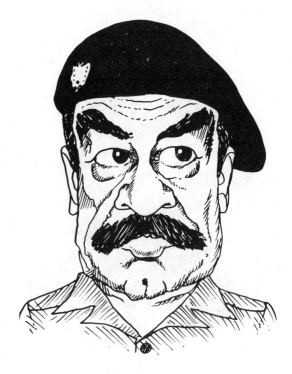

Saddam Hussein has a strong face, consisting of heavy brows, thick mustache, and very large eyes. Like him or not, he has an interesting look about him. I did a quick portrait of him followed by a caricature where I used his beret from another picture. I thought it helped the resemblance.

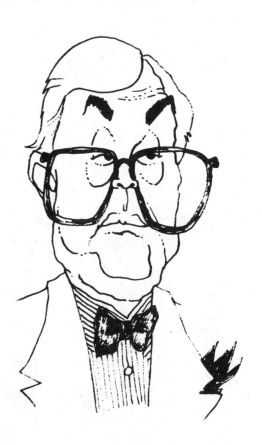

To capture our attorney general I had to concentrate on her slightly bulbous nose, her hair that seems to cover most of her face, but most importantly those extra-thick eyeglasses. Her face seems obscured by hair and glasses, not much face there really.

His oversized owlish glasses were my starting point, combined with his jowliness and large eyes. And naturally his signature bow tie was of great help, along with his face shape.

And what section on political caricature would be complete without Yasser Arafat? He has the perfect face for our purposes: dominant nose, thick lips, squinty eyes, stubby beard on a weak chin, and that wonderful burnoose. Who could ask for more?

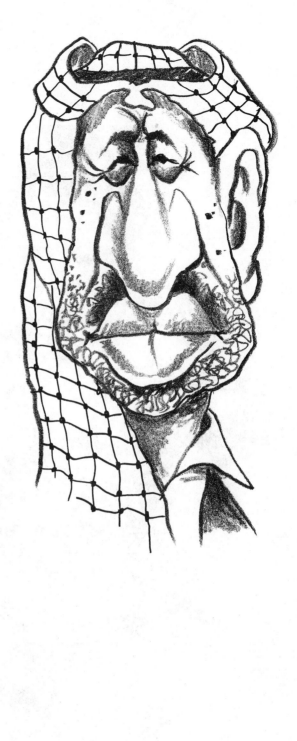

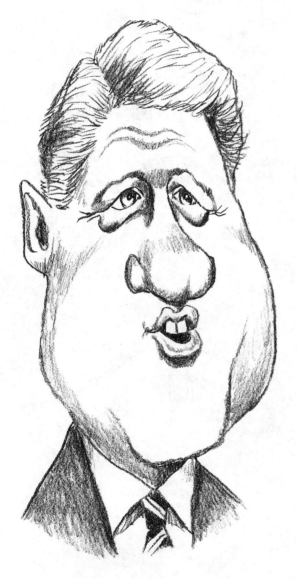

Like all Presidents, Clinton has been done so often that now he's recognizable merely by indicating a chubby face, bulbous nose, and gray hair. At least, some political cartoonists have chosen to use that abbreviated technique. Sometimes if a caricature is repeated often enough, it becomes a set of recognizable symbols, as with FDR and his pince-nez glasses and cigarette holder, or Nixon and his heavy brows and jowly countenance. With Clinton there's a little more to it than that. His eyes pull down at the outer edges for a slightly sad look, and his mouth is full-lipped yet quite small for the rest of his face. Other than that, notice that his rapidly graying hair leans to one side of his head, making him quite asymmetrical, and he has a fairly close forehead.

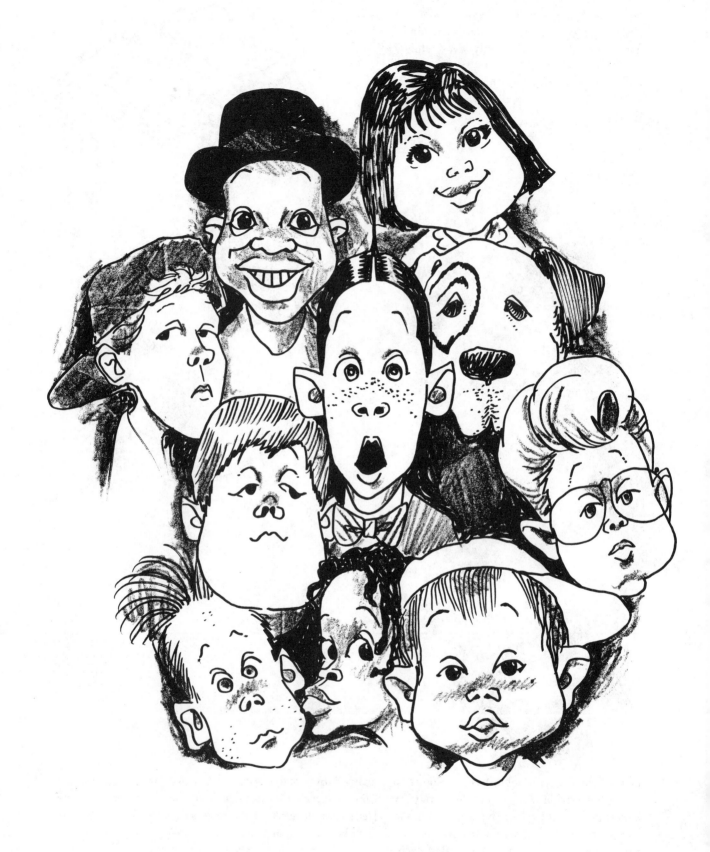

I decided to do each kid's face from the poster
of *The Little Rascals*, the recent remake from
Universal Pictures.

# CHILDREN

Doing caricatures of children poses its own unique challenges, in particular the fact that young people's features are still a bit amorphous, the fact that they all share one characteristic: their brows and heads are large and their chins small. As we age through the teen years, we grow into our heads, so to speak; our chins and jaws lengthen, and our foreheads appear smaller.

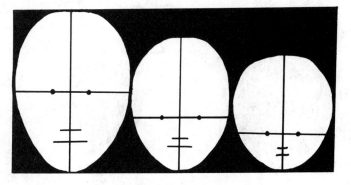

So keep the following in mind when caricaturing children: make their heads larger than normal; be sure the upper half of the child's head is larger than the lower; as a general rule, be sure that they look chubby; and place their eyes wide apart.

107

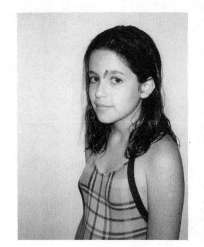

As an example here's pretty little Tory in two poses.

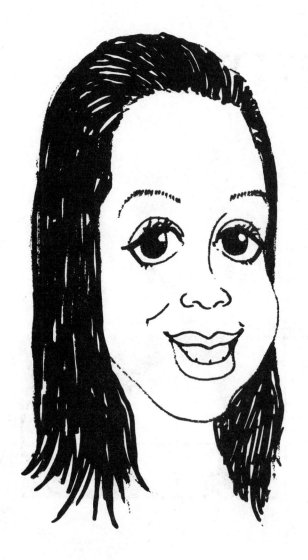

And here are a few more for good measure. Notice how the above rules apply: head large, upper head larger than lower, cheeks full, eyes wide apart.

But if you decide to do caricatures of kids, you might as well go for the whole body. They are such hyperkinetic individuals that it's difficult to separate them from their busy little bodies. Which coincidentally brings us to our next subject . . . (I am truly a master of the segue!)

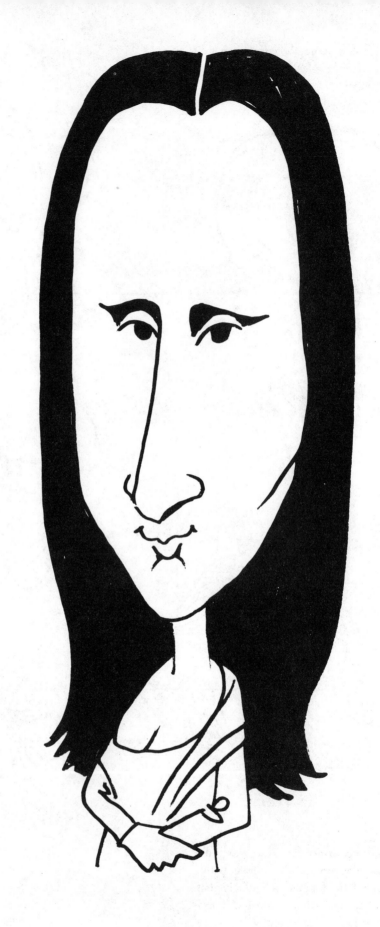

# Bodies

To do a book on caricature and not include the topic of bodies would be a little remiss, and far be it from me to be guilty of that, so . . .

The body is another very important aspect of the art of caricature, which are not always, like most of the examples in this book, disembodied floating heads. The body can contribute a great deal to a caricature; it gives you the opportunity to inject some sort of statement about the subject. You can add props and wardrobe and really round out the caricature, as it were. And as with the face, the body should also be slightly distorted: a slight paunch becomes a beer belly; a thin frame is pictured as no less than skeletal. The person's attitude is also exaggerated: the military man is ramrod stiff, and the rock 'n' roller is absolute jelly writhing in every direction. If your subject slouches, make him droop; if she's chubby, go for fat.

Most caricatures are done with much smaller bodies, and I believe the reason for that is that the face is the primary consideration, making the body secondary in importance. Also the page is usually dominated by the head, lending it additional focus and power.

Following are a bunch of caricatures with bodies and faces unknown to you (unless perchance you know some of my friends), but they provide a variety of examples of how to introduce the small-body concept into the existing caricature. As you can see, these run a wide range, from a moderately small body to a really tiny one, but they all work in their own way. It's again a totally subjective choice as to how large you choose to do the body; that is, unless there are certain props or symbols that you want to be clearly seen. Then I'd recommend going larger.

This first one, however, is *not* a friend of mine. (Hey, I'm not *that* old!) I decided to do a caricature of the *Mona Lisa* just to get things started. It'll give you an idea of how the small body works.

111

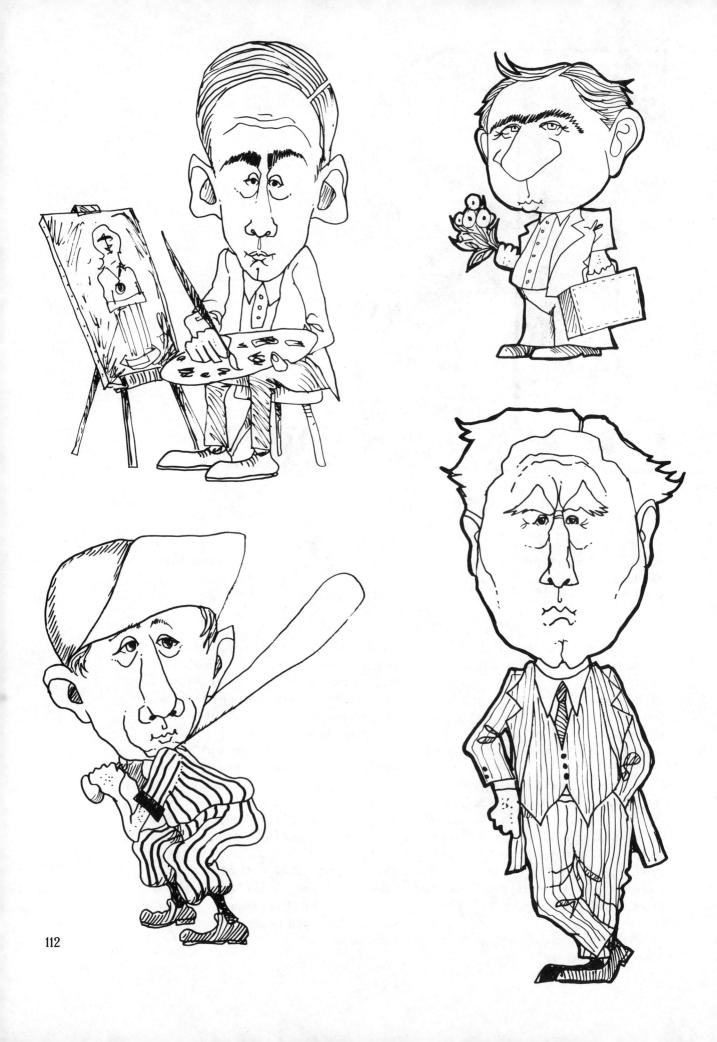

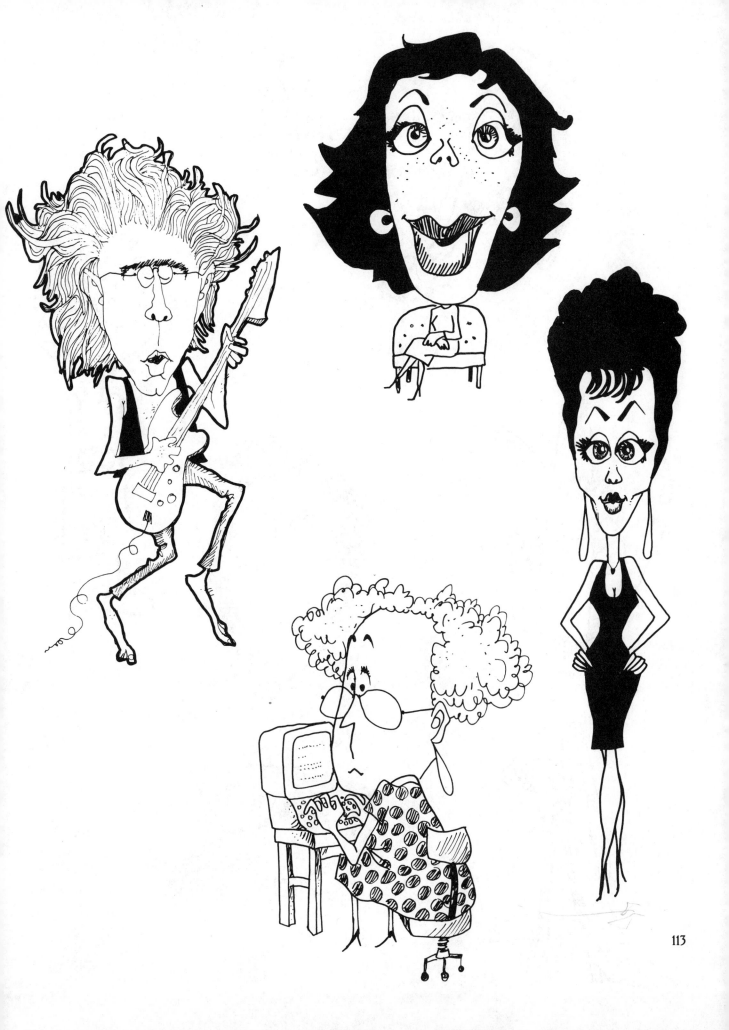

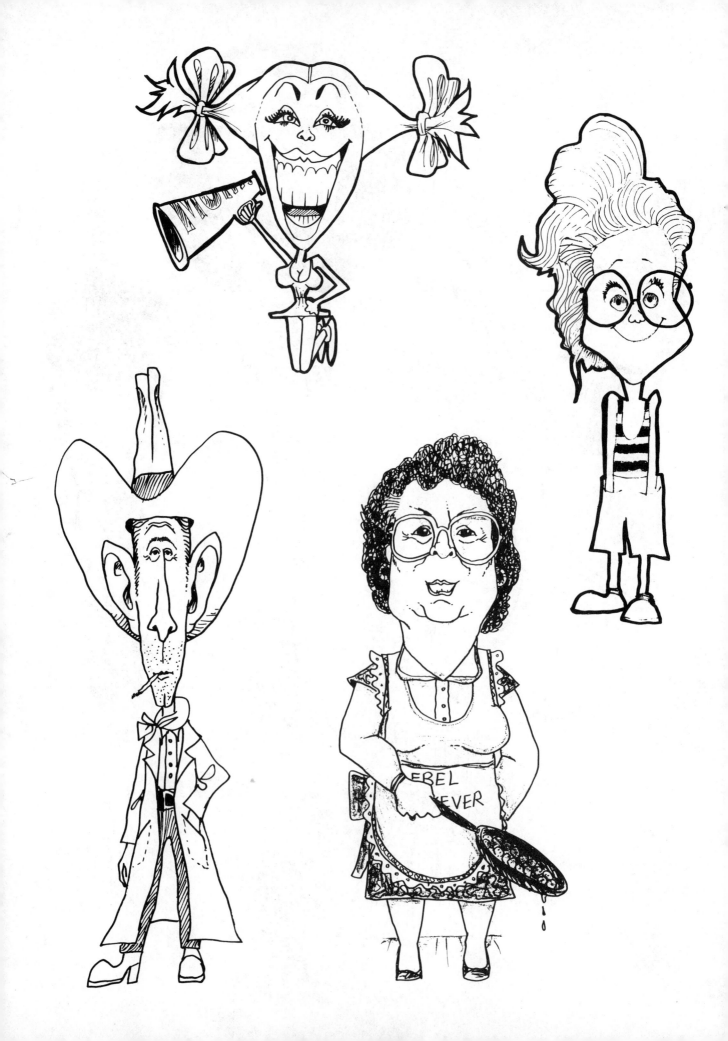

And I've even tossed in a few celebrity caricatures with bodies just to close things out.

Madonna is a woman with very even features. She looks almost beautiful at times, with the exception of that slight gap in her teeth. But this performer's look—her hair color, hairstyle, and outfits—changes so drastically from day to day that it's difficult to ascertain the quintessential image that represents her. I chose the pixie cut simply out of desperation. Regarding her body, I chose to use the missile bras and (naturally) minimal clothing, another cliché attached to her image.

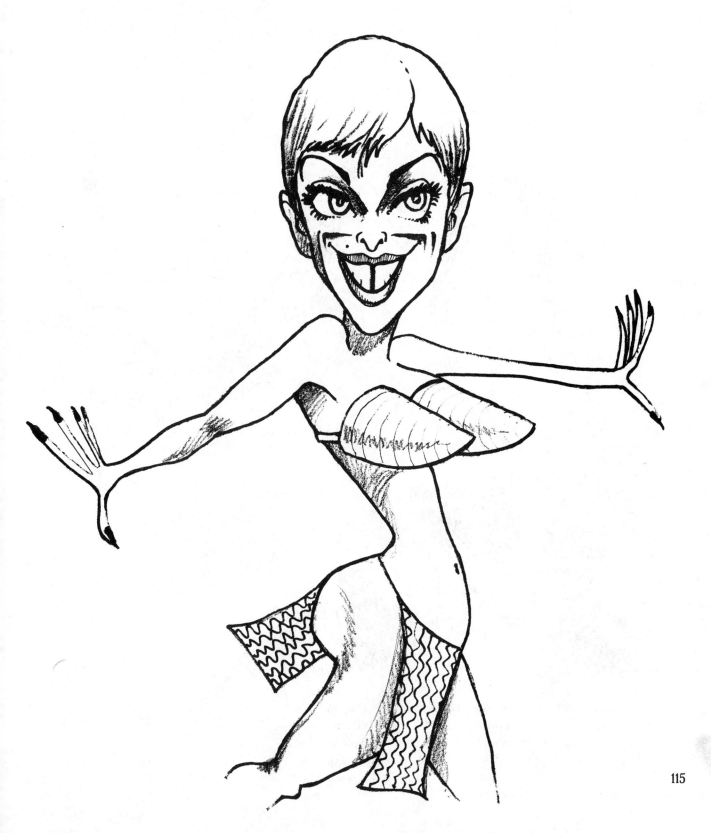

115

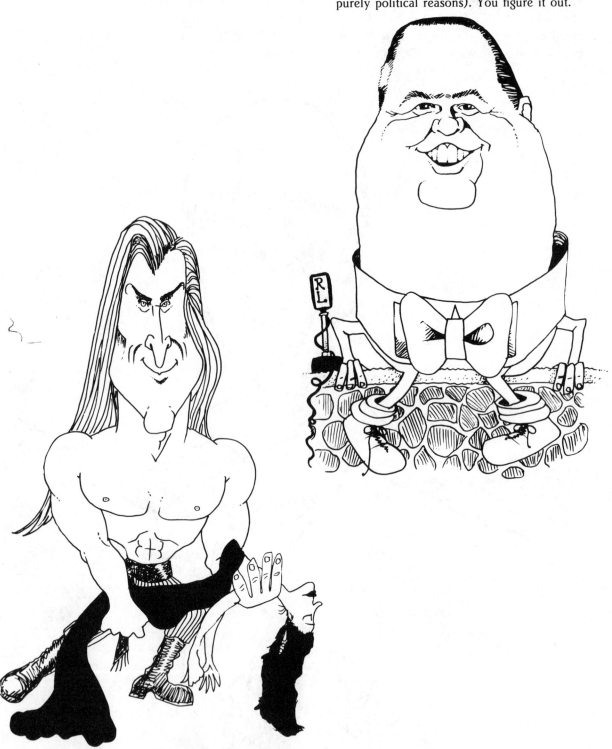

I decided to picture Rush Limbaugh, whom you might remember from an earlier incarnation of mine, as Humpty Dumpty (for purely political reasons). You figure it out.

And here's another take on Fabio. I chose to do him full body because that's part and parcel of who he is. Since he is primarily a physical animal, it would be neglecting a major portion of his identity to exclude his body. He's hardly a talking head.

116

# CLOSING

Drawing to a reluctant close (I'm a sucker for a bad pun), I'd like to remind you that caricature is supposed to reflect a sense of fun . . . not animosity. You can vent a miniscule portion of your spleen in your work, but I think there's enough out-and-out cruelty in the world without really going for the jugular. It's very much like the work of comedians who skewer personalities in their acts, whether it's Don Rickles or one of the new crop: there is a line that performers just don't cross unless they want to risk the wrath or disdain of the audience. When it was faddish to attack Dan Quayle for his numerous gaffes, there finally came a point of saturation when he was such an easy and obvious target that it was no longer funny. It's as if the public merely decided "He's had enough," or "He doesn't deserve any more humiliation no matter how inept he may be." So have fun but also have compassion; let's not lose sight of those words that we associated with caricature . . . Exaggeration . . . Distortion . . . Ridiculous . . . Ludicrous . . . Humorous.

It is my sincerest wish that this book has informed, instructed, inspired, enlightened, and amused you, and furthermore I hope that you may soon join the ranks of those artful anarchists who occasionally grace the pages of our daily papers—the caricaturists. It is a wonderful, powerful, and enjoyable art that, used correctly, can help to keep our often confusing and potentially explosive world in perspective, by injecting it with a badly needed sense of humor . . . So puncture the pompous, lampoon the lazy, ridicule the rest, and who knows, we may even eventually topple some of the tyrants.

Now grab your marker . . . get set . . . and go get 'em.

# About the Author

Dick Gautier was drawing cartoons for his high school paper in Los Angeles when he was sixteen, singing with a band when he was seventeen, and doing stand-up comedy when he was eighteen. After a stint in the Navy, he plied his comedy wares at the prestigious "hungry i" in San Francisco for a year before traveling to the East Coast, where he performed in all the major supper clubs; among his appearances was an extended run with Barbra Streisand at the Bonsoir in Greenwich Village. He was tagged at the Blue Angel by Gower Champion to play the title role in the smash Broadway musical *Bye Bye Birdie,* for which he won a Tony and Most Promising Actor nominations.

After two years he returned to Hollywood, and eventually starred in five TV series, including *Get Smart,* in which he created the memorable role of Hymie, the white-collar robot. In addition, he portrayed a dashing but daffy Robin Hood for Mel Brooks in *When Things Were Rotten.*

Add to this list guest-starring roles in more than 300 TV shows, such as *Matlock, Columbo,* and *Murder, She Wrote,* and appearances on *The To-night Show,* and roles in a slew of feature films with Jane Fonda, Dick Van Dyke, George Segal, Debbie Reynolds, Ann Jillian, James Stewart, etc., etc. He has won awards for his direction of stage productions of *Mass Appeal* and *Cactus Flower* (with Nanette Fabray), and has written and produced motion pictures.

Gautier is the author/illustrator of *The Art of Caricature, The Creative Cartoonist, The Career Cartoonist: Drawing & Cartooning 1001 Faces,* and *Drawing and Cartooning 1,001 Figures in Action* for Perigee Books, a children's book titled *A Child's Garden of Weirdness,* and two coffee-table books with partner Jim McMullan titled *Actors as Artists* and *Musicians as Artists.* He's done just about everything but animal orthodontics, and don't count him out on that yet. No wonder he refers to himself as a "Renaissance dilettante."

Of all his accomplishments, Gautier is proudest of the fact that he's never hosted a talk show, or gone public with tales of drug rehabilitation and a dysfunctional family life.

# *Learn to Draw*

## with Illustrated Instruction Books from Perigee

### *By Dick Gautier:*

_The Career Cartoonist      0-399-51732-4/$12.00
_The Creative Cartoonist      0-399-51434-1/$11.00
_Drawing and Cartooning 1,001 Caricatures      0-399-51911-4/$11.00
_Drawing and Cartooning 1,001 Faces      0-399-51767-7/$10.95
_Drawing and Cartooning 1,001 Figures in Action      0-399-51859-2/$10.95

### *By Jack Hamm:*

_Cartooning the Head & Figure      0-399-50803-1/$9.95
_Drawing and Cartooning for Laughs      0-399-51634-4/$9.95
_Drawing Scenery: Seascapes and Landscapes      0-399-50806-6/$9.95
_Drawing the Head & Figure      0-399-50791-4/$9.95
_First Lessons in Drawing and Painting      0-399-51478-3/$10.95
_How to Draw Animals      0-399-50802-3/$9.95

### *By Tony Tallarico:*

_Drawing and Cartooning Comics      0-399-51946-7/$9.95
_Drawing and Cartooning Dinosaurs      0-399-51814-2/$7.95
_Drawing and Cartooning Monsters      0-399-51785-5/$9.95
_Drawing and Cartooning Myths, Magic and Legends
     0-399-52139-9/$8.95

### *Also Available:*

_The Art of Cartooning *by Jack Markow*      0-399-51626-3/$9.00
_Drawing Animals *by Victor Perard, Gladys Emerson Cook and Joy Postle*
     0-399-51390-6/$9.00

_Drawing People *by Victor Perard and Rune Hagman*
     0-399-51385-X/$9.00

_Sketching and Drawing for Children *by Genevieve Vaughan-Jackson*
     0-399-51619-0/$8.50

---

Or check above books and send this order form to:
**The Berkley Publishing Group
390 Murray Hill Pkwy., Dept. B
East Rutherford, NJ 07073**

Please allow 6 weeks for delivery

Name_____

Address_____

City_____

State/ZIP_____

Bill my: ☐ Visa ☐ MasterCard ☐ Amex    expires _____

Card #_____
                                 ($15 minimum)

Signature_____

Or enclosed is my:      ☐ check    ☐ money order

Book Total      $_____

Postage & Handling      $_____

Applicable Sales Tax      $_____
(NY, NJ, PA, CA, GST Can.)
Total Amount Due      $_____